IN SEARCH OF THE JERICHO POTTERS

NORTH-HOLLAND CERAMIC STUDIES IN ARCHAEOLOGY

VOLUME 1

Editor:

H. J. FRANKEN
University of Leyden

1974

NORTH-HOLLAND PUBLISHING COMPANY
AMSTERDAM · OXFORD
AMERICAN ELSEVIER PUBLISHING CO., INC.
NEW YORK

IN SEARCH OF THE JERICHO POTTERS

Ceramics from the Iron Age and from the Neolithicum

H. J. FRANKEN
University of Leyden

1974.

NORTH-HOLLAND PUBLISHING COMPANY
AMSTERDAM · OXFORD

AMERICAN ELSEVIER PUBLISHING CO., INC.
NEW YORK

Library of Congress Catalog Card Number: 74 - 84738

North-Holland ISBN: 0 7204 8025 6
American Elsevier ISBN: 0 444 10763 0

PUBLISHERS:
NORTH-HOLLAND PUBLISHING COMPANY – AMSTERDAM
NORTH-HOLLAND PUBLISHING COMPANY, LTD. – OXFORD

SOLE DISTRIBUTORS FOR THE U.S.A. AND CANADA:
AMERICAN ELSEVIER PUBLISHING COMPANY, INC.
52 VANDERBILT AVENUE, NEW YORK, N.Y. 10017

PRINTED IN THE NETHERLANDS

Contents ‹ 5

6 Contents

Contents

Part Two
METHODS OF POTMAKING IN NEOLITHIC TIMES
AT JERICHO

List of Charts

Part One

Part Two

Part One

Part Two

The decoration with red paint is indicated with a
black field; to the left of the vertical axis in-
dicates paint inside, to the right paint outside.

POTTERY STUDIES BASED ON ANALYTICAL MODELS

"The ways in which man has used clay to make
 vessels for his needs are myriad"
 F.R. Matson, 1960

The quotation expresses a truth the importance
of which has not been fully grasped by the archae-
ologists. If each potter in antiquity used many
ways to make pottery, then pottery studies will
remain an unreliable tool in archaeology. If, on
the other hand, each one of all pottery workshops
or pottery making families that ever existed can
be distinguished by one of the "myriad" ways in
which they used clay to make vessels, our pottery
studies could become very simple in theory. What
has to be done now is to find out to what extent
Matson's rather exclamatory statement is true.
There is a fair chance that Matson is right to a
certain extent. But in his article from which the
quotation is taken he does not seem to have gras-
ped the full consequences of this idea.
 The main thesis of the studies that are to be
published in this Series is that a model which
comprises all the elements that characterise one
kind of pottery is likely not to have an identical
'twin' in history and therefore can be used to
solve a great many problems which until now seem
insoluable. The crux of the matter is that attri-
bute analysis in the case of pottery remains sub-
jective as long as the methods of potmaking em-
ployed by the potters are not properly analysed.
 The use of the word 'model' includes a criti-
cism of all attempts to describe pottery, attri-
butes, etc. by presenting observations without
making an attempt to explain why these observa-
tions are relevant. The elements that characte-
rise one kind of pottery are those elements that
can be shown to be coherent. And the coherence of
characteristic elements can be demonstrated by the
analysis of the production processes of pottery in
the workshop. This includes more than the analysis

of the methods of making individual pieces of pot-
tery (Watson, LeBlanc & Redman, 1971 (1)). The
results of such studies are expressed in models
that can be scrutinized, tested by experiment and
by further study of the material.

 Models are designed by scientists to explain
what happens in a system. If it turns out that
the system does not always (re)act according to
the laws expressed in the model, the last one has
to be revised. In our pottery studies there is
one element that seems to escape from the defini-
tion of a system. Pottery shapes are looked at as
free artistic creations on the assumption that
shape cannot be explained.

 Pottery is however a product of physical and
chemical processes put into action by man, after a
struggle with a mixture of raw materials to create
certain shapes. The description of this whole
composite system of physical, chemical and psycho-
logical laws takes on the shape of a model because
at the moment dried pottery is fired, not only the
paste but also the method of potbuilding is tested
by the fire. Since pottery studies are to be in-
tegrated into larger archaeological contexts and
result in descriptions of cultural processes in
the past, our explanation of the phenomenon of
pottery has to be presented in a form which can be
tested for its value by rigorous scientific means.

 The reader may doubt the value of the express-
ion 'psychological laws' in this context, but it
is exactly this feature which badly needs to be
expressed in a model (Morgan, 1973). The present
writer works on excavations in the Near East that
yield masses of potsherds every day, and is used
to archaeological publications filled with pottery
studies that seem to lack a modern scientific
approach. Those pottery studies are based on the
assumption that there was continuity in the pro-
duction of pottery shapes and that the individual
pots or groups of pottery from different sites
which look similar can be compared. This supposes
the existence of 'laws' that express themselves in

the activities of the makers of pottery. Supposed-
ly there are laws of continuity or laws of simi-
larity, etc.

Pottery shapes are described but not explained.
As long as we cannot explain pottery shapes we
cannot demonstrate that different shapes found to-
gether have any relationship and belong to one
kind of pottery. We suppose that there are cases
in which a certain type of pottery was made during
long periods, but there is no real explanation for
it. Once a method has been designed to explain
shape in such a way that all shapes of one kind of
pottery are explained in one formula, we can
demonstrate whether there was continuity or not.
We can also demonstrate whether there is real
similarity between groups or not.

'Type' of pottery is not used here in a clear
defined sense. Types of pottery are distinguished
by names derived from localities, periods, or
techniques, like Samaria ware, Iron I, or bichrome
ware, all three from Palestine. They are just
names used by the initiated. They have no des-
criptive value. Shape descriptions have taken on
many forms. Archaeologists working in the Near
East mostly seem concerned with questions of re-
finement of the existing methods of description of
pottery shape, terminology, etc., studies that do
not fundamentally solve the problems of uniformity
(Smith, 1970; Ericson, Stickel, 1973). This can
only come from an understanding of the structure
of pottery. In archaeological reports descrip-
tions are usually defective since no standard
nomenclature is used for shape description,
temper minerals, etc., but this lack of uniformity
and completeness is 'compensated' by the use of
drawings. These drawings are sometimes 'realistic'
but mostly rather schematic representations of
shape. Notes about color, hardness, temper are
added for each individual pot that is published.
These descriptions do not seem to play a sub-
stantial role in typologies or in comparative
studies. As far as no standardized scales for the

measurement of these features are used these des-
criptions belong to the secret language of the
initiate allowing for a large margin of error. By
adding this information to each published drawing
the typologist in fact indicates that it is not
part of the type description because it contra-
dicts the idea of type. Or, it virtually makes
each pot a type of its own, incomparable. Lack of
understanding of the structure of pottery is res-
ponsible for this ambiguity. The typologist is
not sure whether a difference in color between two
pots has typological significance or not. Type is
nearly always identical to similarity of shape;
descriptions of color, hardness, grit, etc. fall
outside of the type characterization. In this
system two different kinds of temper can be inclu-
ded in one type of pottery. It is very unlikely
from a technological point of view that this is
right. As a rule different temper groups indicate
different type groups.

I have mentioned a few assumptions of pottery
studies. They are used as axioms. But whether
these axioms can be trusted still has to be demon-
strated. As is so often the case, one does not
probe the axioms as long as there are no alterna-
tives. But the assumptions are not real axioms;
it can be demonstrated that they are false.

The accepted reasoning based on such assump-
tions runs somewhat as follows.

Let A indicate a group of pottery, properly
described in the traditional way. Let A1 and A2
indicate 'successive stages of development' of
group A. Then it follows that
(1) If there is a stratigraphical sequence A, A1,
A2, etc. at one site, then A1 originated from A,
A2 from A1, etc.,
(2) Any A, A1, A2 etc. group found at one site is
typologically comparable to A, A1, A2 etc. group
found at any other site and they are interchange-
able,
(3) If group A is followed by groups A1, A2 etc.
at one site then this can be used to make a

chronological statement about groups A, A1, A2,
etc. found at other sites.
Before we accept the validity of these presupposi-
tions as a basis for our chronological and compa-
rative studies, we have to explain why and how A1
must have descended from A, A2 from A1 at one and
the same site and we have to explain why group A
from site N is comparable to group A from site M.
Similarity in appearance cannot be taken as proof
of real identity. To take things for granted is
not helpful in solving problems of verification.
These suppositions do not explain what we are
doing and why we do it. In fact since we have no
means of verifying we have been caught in a pheno-
menological trap (Binford, 1972).
 Common sense has done a lot to promote progress
in archaeological pottery studies. But the draw-
backs of the use of the above mentioned 'axioms'
are becoming increasingly manifest.
If we assume that a certain type of pottery is a
system that can be used to define a (pottery)
cultural area, we have to explain how that system
is functioning. Therefore we shall have to dis-
cover and describe the laws, from the macro world
of the (pottery) cultural unit to the micro world
of the shape and other features of a type.
 I have to define the meaning of some expres-
sions that will be used in one sense only. The
problems of the definition of artefact types have
been extensively discussed recently (Clarke, 1968;
Watson, LeBlanc & Redman, 1971 (2)). The subject-
ive elements in the choice of the attributes that
define a type present a problem. Below, an at-
tempt is made to demonstrate that an analysis of
the system can make the choice of the attributes
less subjective. Then we can also give a better
definition of pottery type. 'Repertoire' is used
here to indicate all pottery (fragments) that is
excavated from one level, phase or stratum at one
site, whether this pottery seems to form a homo-
geneous group or not and regardless of the quest-
ion whether it stems from one period or not. It

indicates all the pottery that was present in the
excavated level. What is to be considered as one
level is not discussed here. It is supposed to
represent one slice of time.
'Tradition' is an abstract expression. It indi-
cates that part of the production of a pottery
workshop that supposedly in origin was the produce
of one single way of making pottery.
'Kind of pottery' is a neutral expression to be
defined more closely when talking about the basic
model. A pottery workshop can produce different
kinds of pottery that originally were not produced
at one and the same place, nor do the origins have
to date from the same cultural period. Thus a
pottery workshop produces pottery stemming from
one or more traditions.

 I shall begin with the abstract notion: the
tradition.
Let there have been a tradition of potmaking. Then
we have to assume that a group of people like a
family had learned from their predecessors and
were engaged in transmitting to their followers a
highly complicated set of rules, behaviour, re-
cipes, techniques, in short a vast amount of tra-
ditional knowledge, the basic elements of which
can be reconstructed. Such a group must have had
knowledge of where to find the proper raw materi-
als, what should not be used as raw materials, the
method of collecting and preparing these materi-
als, the method of shaping the paste into pottery
shapes, the method of drying the finished shapes,
the right type of fuels to be used for the fire,
the type of fire or kiln to be constructed, the
method of stacking the dry pottery, the method of
stoking the fire or the kiln, the method of let-
ting the fire extinguish and the method of packing
the fired pottery for transport and the distribu-
tion of the product. In the whole production pro-
cess they knew what to do and what not to do.
Apart from that there were all the other elements
of their ways of life, handed down to them by
their ancestors and equally important to them like

the tabu's, the offerings, the prayers, the mar-
riage regulations, etc. (Balfet, 1966).

Those elements listed above of which the pot-
ters must have been aware, those things the pot-
ters knew how to do, can to a large extent be re-
constructed from the study of the repertoire. By
reconstructing this knowledge we also discover
what the problems were from the potter's point of
view, that resulted from the type of raw materials
used, the measure in which the method of shape
making was in agreement with the type of paste and
indeed many other difficulties the potters had to
overcome. It should be stressed here that in
terms of our model constructing, it is indicated
that potters were really producing pottery accord-
ing to a fixed pattern. They may have picked up
the production of a different kind of pottery, for
instance a special recipe for the production of
cooking pots, a 'fireproof' vessel. Then they
work according to two traditions for specific
purposes.

A repertoire represents a slice of time out of
one or more traditions, made visible in the pot-
sherds excavated from one level. We usually do
not know exactly how much time is represented by
that slice. But we suppose that it is a slice out
of a continuum, that it is based on a history and
that it had a continuation later. Let us suppose
that we are dealing with A1. We suppose that
there was an earlier stage of the tradition, A,
and that there is an A2 group, a later group.
We still have to demonstrate that this supposition
is right and that the sequence is not B, A, C.
A is a repertoire, but does it represent one tra-
dition? The first step is to see if it consists
of one system of making pottery. This can be ana-
lyzed to a large extent. Here some of the prob-
lems involved have to be indicated.

Let us suppose that this repertoire can be di-
vided into two groups of pottery, because two
kinds of temper were used. One part of the pot-
tery is tempered with grog and the other part with

quartz sand. The grog must have been added on
purpose, because grog does not occur naturally in
clays. Quartz grains are often encountered in
sedimentary clays. It has to be decided whether
the quartz sand was dug with the clay or whether
it was added by the potters. In other words
whether the clay was a silty or a non-silty clay,
with quartz sand added. The question is simpli-
fied here, because there is another possibility,
namely of a silty clay being tempered with quartz.
But if we compare the paste of the grog tempered
pottery with that of the quartz group, we will
either find that the grog group also contains
quartz in the same amount as the quartz group and
the same grain size, or it does not. In the first
case it is possible that the same clay was used for
both groups, and that for some reason sometimes
grog was added and sometimes the clay was used as
found in nature. In the second case there are more
possibilities to choose from but one thing is clear
: the potters did make a distinction between the
temper groups and they must have had a reason to do
so. In order to trace the reasons for this dis-
tinction we have to separate the two groups.
 The next question then to be asked is: what are
the properties of the two types of paste in view of
the usefulness for making pottery in a certain way.
Is there any direct relation between clay, type of
temper and the way the pottery was made? And if
this question seems too farfetched, can the two
groups also be distinguished by the manufacturing
methods? Only after the separation of the two
groups can we see if there are significant differ-
ences in shape. But even if the differences are
considered insignificant we have to analyze the
methods employed to make pottery. If differences
are found we have another aspect that needs expla-
nation, but this is also the case when there are no
differences. This is probably more difficult to
see, but it is possible to mention some reasons.
Why should potters collect broken pottery and pound
it to powder, or use wall fragments of broken down

kilns for that purpose when at the same time they
knew where to find sand that could be collected
and used as it came? This question cannot be ig-
nored. The report on the Iron Age pottery from
Jericho shows that the ceramic history of a short
period and at a site that was certainly not the
center of the economic, social or religious life
of the time, is far more complicated than a typo-
logy based on shape analysis could ever reveal.

At this point the concept of tradition plays a
very important role. If our repertoire consists
of two temper groups, we are dealing with two
traditions. There are many possible explanations
but one cannot be accepted, namely that one day
the potters used grog and the next day quartz
sand even if it could be shown that these materi-
als were interchangeable without affecting the
production and the products, which is not so.
The study of the Neolithic pottery from Jericho is
a lively illustration of the influence of differ-
ent tempers on potmaking in one method. Temper
does affect the possibilities of shaping pottery
and other aspects of potmaking. The Neolithic
pottery is exemplary of the implications of a
complex situation like different tempers found in
'one kind' of pottery. This pottery supposedly
belongs to the earliest period of potmaking. The
results of the technological analysis give reason
to suppose that there must have been earlier
stages. It strongly suggests that potters were
exploring the possibilities of different temper-
ing materials. Clearly, they found out something
about the influence of temper on shape and on
other features.

This rigid system expresses itself in the way
the pottery is built. Not much can be said here
about the analysis of the pot building methods.
Every methods of shaping clay leaves traces on the
surface. Often the potter has erased these traces
when finishing the pot by smoothing the surface
with a rib, a wet cloth, or leather. But if the
whole repertoire is studied, that is, if no pre-

liminary selection is made before the material is
subjected to this analytical study, there usually
are enough sherds that betray elements of the
method that was employed. Shape can be indicative
of what could have been used as a temper and what
could not have been used. There are shapes that
cannot be thrown. Coarse temper cannot be used for
throwing. But there are many indications and,
what is more, there are many more methods of mak-
ing pottery than is known from the existing
archaeological literature.

In our definition tradition indicates one sys-
tem of making one kind of pottery. Part of this
system is the actual shaping of vessels. Once the
methods of potmaking found in one repertoire have
been analyzed, or in terms of a model, we have
found the most likely explanation of how the pot-
ters made their vessels, we may have found one,
two or more methods, each one resulting in one
kind of pottery. In each case we have found a set
of manipulations. When making different types in
one tradition some of the manipulations are iden-
tical for two or more types. If we give each
manipulation a number, each type within the tradi-
tion can be indicated by a set of numbers. From
a scheme we can see that each type belonging to
one kind of pottery is represented by a figure
different from the others. This formula becomes
part of the model. This is immediately followed
by a formula which indicates the numerical rela-
tionship between the types. This is indispensible
as I will argue below.

Preceding the type-formula we need a descrip-
tion of the raw materials, not only of the temper
groups, also as much as possible of other impuri-
ties found in the clay body, and then follows what
can be found out about the plasticity of the clay
paste and other aspects of the potmaking process.

The whole study is based on tests. Arguments
can be settled by repeating the tests. Mr. Jan
Kalsbeek, a professional potter with a broad
knowledge of and interest in historical techniques

of potmaking, is putting his analysis of the manu-
facturing methods to the test by actually making
the pottery under study. This process goes through
a number of experimental stages. The thin-slide
analysis can be supplemented for instance by a
search for heavy minerals, and by a comparison
with clay samples taken from the site and its
surroundings.

The analysis of the methods of potbuilding is
based on the study of traces left on the surfaces
and knowledge of the mechanical forces generated
by the manipulation of the clay. Needless to say,
what are usually considered as valuable materials
for study: rims, bases, etc., are not sufficient
for this purpose; large quantities of body sherds
are included in the study. All the various traces
found have to be listed and described. Next, the
logical order of the analytical process has to be
argued. For each type one can give the limits of
variability in different parts of the pot, and if
need be, some of the variations are drawn.

When working with pottery fragments only, there
will be bases and body sherds, sometimes also
fragments of other parts that can be attributed to
more than one type. This follows logically from
the model which shows the overall unity of the
tradition because those parts that are the result
of the same treatment are identical in shape. This
in turn gives us the chance to test the model from
the statistical angle. For example, bases can
often be classified into small bowls, large bowls,
small and large jars. The number of bases found
can be counted with a fair amount of accuracy.
Rims, which may break into many more fragments
than bases, can however also be counted. By
comparing the two groups we find agreement or a
mistake in the analysis.

Once a pot is fired it is difficult to know
exactly the working properties of the clay mixture.
Yet it is possible to find out a lot about it: the
clay was plastic or lean, or in between. The
paste had good adhesive quality: coils and handles

do not come off. The degree of shrinkage can be
judged from the way the handles are placed, be-
cause drying is not even in the body and in the
handle. When two different types of temper are
used in one pot, like one kind of temper in the
base and in the handle, and another in the coils
(Late Bronze Age, Deir cAllā), one knows what the
problem was. A base is literally basic for the
story of the construction of a pot. How were they
made? Did the potter start with the base or fin-
ish the pot by making the base?

Let us now turn to our hypothetical groups A
and A2, having described A1 in a model. A1 is the
pottery from one level at one site. A represents
the previous level and A2 the one following A1.
We have to go through the whole routine again in
both cases in order to be able to compare the
models. If we find no differences at all, we are
justified in saying that the three groups are
identical. In that case they have no value for
dating. If however the models show a slightly
different position of the potter's fingers while
he was finishing the rims, the models are not
identical. If it is only that, we assume that
there was a development in the tradition. It may
be that other aspects show development: improve-
ments in the construction of some types. Or im-
provement in the construction of the bases.
The most eloquent example of this process we found
when studying the Iron Age pottery from Deir cAllā
(Franken-Kalsbeek, 1969). It was a process that
lasted for many years. The problem was that the
majority of bowls and jars showed cracks in the
bases after firing. When the stage of experimen-
tation which could be analyzed step by step was
over, a completely new technique had been devised:
turning the pot closed upside down. Instead of
starting with the base the potters finished making
the vessel by shaping the base. Technically,
their problem was from the beginning the control
over the thickness of the base. They solved it
beautifully. The result was that the large jars

had a different shape after the solution had been
found. One can find in the literature the four
main steps of experiment and improvement as four
different types. It was still the same jar but it
changed type, so to speak. So what is a type?
Types in shape typology are not types.
I know that this is unorthodox but I maintain that
there is no good definition. In these reports a
type is what is the result of one fixed set of
manipulations of the potter with clay. One dif-
ferent manipulation results in a different type.
This does not quite solve all the problems. It
sounds logic that potters did different things to
make different types. From collections of rims,
however, it soon becomes clear that there can be
'transitional' forms, especially with folded rims.
When experimenting we have come to the conclusion
that it is possible to make clusters around the
types as defined by the model. This is especially
possible if one has large quantities of pottery
fragments. Then one finds also the reason for the
differences. There are two. (a) The amount of
clay still available from which the rim is to be
made, be it while throwing or coiling. In both
cases the amount can differ, because the thick-
ness of the wall can be slightly different in each
case. The thickness is related to the volume of
the pot, if we can assume that each time the pot-
ter started with roughly the same amount of clay.
And it can be observed that potters do often have
a pretty good eye for quantity of clay and pro-
portion. The other possibility (b) is also found,
the otherwise clearly defined shape of the rim has
not 'come off', it remains rather indistinct.
The next problem to be considered in this respect
is that of the changes a type may undergo in the
course of time. If such a change did occur and
was indeed limited to the shape then it follows
that the potters changed the position of the
fingers while working the clay. The changes may
be so minute, especially while making rims that it
can hardly be expressed in our description of

shaping the pots in the model. There is however
another method of testing changes and the rate of
change. If it appears that a change took place
without a sudden jump but almost inperceptibly,
there must have been a tendency to move from one
given method to another. This tendency again can
be traced by making clusters. Thus it could hap-
pen that from a rather wide cluster in stage A a
much narrower cluster is found in stage A1 which
formed around one element found rather off center
in the cluster of stage A. Our stages A and A1
represent together again one slice of time of the
tradition and we often do not know where this
slice of time has to be divided. We are dealing
with a dynamic process cut in two pieces and each
is compressed to one single plane: the level of
our stratigraphy. All we can do is to try and
divide the slice in as many parts as possible in-
stead of the two we already have and see how the
clusters look. This will then demonstrate that
the history of the tradition is a dynamic process
but each time we make a typology of one level, we
damage the record of the process and sketch a
static picture. Always assuming that there was a
dynamic element in the tradition we must conclude
that a typology of the pottery of one single level
cannot be a true record, however meticulously
drawn up. From one-level pottery it is impossible
to define the centers where the dynamics of the
tradition are working. We cannot decide which
element in the cluster is so to speak in focus
when taken from the dynamic forces.

It may be well to remember here that archaeo-
logists have always assumed that development took
place, and it can be stated that whatever was be-
hind the development, it was not artistic whim as
a rule. On the contrary, in several of our stud-
ies it can be clearly demonstrated that the inter-
action between chemical and physical processes and
human routine action is trying to find a 'balance
of forces'. This can be a long process. Once a
balance is obtained some influence from outside or

inside may start up the process again.

One-level pottery typologies cannot be taken as
definite, for two reasons: it cannot be demonstra-
ted that the type of pottery was not subject to
changes and it cannot be demonstrated that in the
case of changes, the typology pinpoints the depth
of the stream.

We have seen that clusters and cluster analysis
demand numerical evaluation. Our model is not
complete as long as the clusters have not been
analyzed. To be sure, I do not say that the
archaeologist fails if he does not produce enough
pottery to do this arithmetic, but I state that
the model can only be trusted as far as these
elements are known. If so, the model is still
only a model. Beyond the model we cannot go.
But we can use it. Even our cluster analysis of
single types will prove to be extremely useful
when comparing sites with 'identical' pottery.
Our model contains up till now the following
elements:
> The analysis of the raw materials from one
> level,
> The treatment of the raw materials from that
> level (potmaking activities),
> The numerical relationship between types and
> the clusters of each type from that level.

We have hinted at the possibility that two or
more models are found inside one repertoire, some
of which may be represented by one type only; what
has to be done with them will follow from the next
steps.

If there is a tradition, there is a history of
that tradition. The origin of a tradition will
be, almost on principle, for ever unknown. All we
can do is to follow the trail back as far as it is
preserved and can be found. Let us take a simple
situation, often found on a Near Eastern tell.
Our repertoire turns out to be composed of two
models and some pots which seem to have come to
the site through normal processes like trade, or

brought by travelers. Let us assume that the sec-
ond model is only represented by one type, the
cooking pot, a fireproof vessel. We have designed
two models, because raw materials and production
methods are different, not even the shape of the
cooking pot can be compared with that of other
bowls. This is the case in Palestine in the Iron
I in contrast to the preceeding Late Bronze II
repertoire. There are three possibilities. The
potters producing the local pottery also made the
cooking pot or they did not, in which case the
cooking pot was made by another group of potters.
Then the distribution of the cooking pot need not
have been tied to the tradition in which the rest
of the repertoire stands. For the 12th century
B.C. in Palestine this can be demonstrated to be
true. The cooking pot distribution is wider than
that of other pottery types. The third possibili-
ty is that potters, stemming from different tradi-
tions shared the recipe of making the cooking pot.
If, as it seems to be the case, this same cooking
pot is occasionally found in a Late Bronze con-
text, we obtain another indication that the pot
was not tied to one repertoire, but made and
traded independently. In theory then, when fol-
lowing up the trail of the two traditions, there
may come a point where one trail breaks off, the
other continues. Two traditions found together
need not come from one cultural period. It is
only when we succeed in picking up the other trail
again somewhere else that we can conclude where
for the first time the two traditions met.

 A method of potmaking may change to such an
extent that certain aspects look quite different.
The only way to demonstrate that A1 developed from
A is to describe from the material evidence the
transitional stages step by step as a logic de-
velopment. There are methods of potmaking that do
not permit development. Pottery made in leather
moulds has straight sides. It is impossible to
make spherical shapes as long as such a mould is
used. Other methods of potmaking allow for

changes within the limits of the method. The
report on the Neolithic pottery in this volume is
an attempt to follow such a development step by
step. Only in this way can we accept the assump-
tion of continuation in the production of a cer-
tain kind of pottery.

Whether pottery from different sites can be
compared for the purpose of chronological studies
demands a larger program of technological analysis
each time the question arises. We assume that
there were two potters working side by side. One
was more conservative than the other. When the
site is excavated the repertoire contains the
products of both potteries. The typologist who is
studying this pottery does not suspect that he is
dealing with a complicated situation. But if
those two potteries were situated at some distance
from each other and their products were found at
different sites, the earliest pottery from both
sites was identical because both came from the
same tradition. Site MA pottery is comparable
with site NA pottery. Site MA1 pottery is still
identical to site MA pottery, but site NA1 is
slightly different from NA. Consequently level
MA1 pottery is dated by comparison with NA pottery
etc. The supposed 'law of similarity' is based on
circular reasoning. Synchronisation based on
comparative pottery studies is only reliable if
the two groups are found isolated and mixed, in
which case we need the material from at least
three sites. This leads to the question of pot-
tery markets.

A pottery market may be stocked by one or more
potteries and those potteries may work for one
market or for several and, depending on where
these potteries were located they may work for the
same or for different markets. Often in the pub-
lications of pottery from the Near East selected
pottery from the excavated site is compared with
selected pottery from other sites. But, if pot-
tery from different sites can be compared because
it came from one market or from one production

center, all the pottery is comparable.

The first step towards reliable comparative studies is to compare traditions, and not individual pieces. The problem is of course that from pottery groups in publications one cannot isolate traditions. Only too often the published pottery is already a selection from the repertoire that was made for the purpose of dating only. No one looking at the repertoire from Iron Age Jericho in the accepted way with knowledge of the 7th century pottery from Palestine suspects how complicated that group is. Our models indicate that possibly there was a local pottery industry but a lot of the pottery was not made at the site and it came from different traditions. From the same period we have a repertoire from Deir cAllā where a large sanctuary was excavated. This repertoire is composed of locally made pottery, pottery that came from the West across the Jordan and pottery that was brought to the sanctuary from the Eastern mountains (Martin, 1974). Without this meeting point of traditions from the East Bank and from the West Bank, Jordanian pottery would be wrongly dated (Power & Franken, 1971).

It should be clear that a pottery tradition cannot a priori be considered to represent a cultural, let alone an ethnic unit. If potters, accustomed to working in the Taurus mountains in Turkey had to move to the Euphrates Valley, they would never be able to produce the same quality pottery as the Taurus mountains clay allowed them to do. They would have to learn to produce good pottery again by trial and error, and we would probably not even notice any relationship between the two groups. If on the other hand the population in an area was really pushed out by new settlers, the potter's tribe (often not from the same stock as the villagers) may have taken refuge until the storm was over and then continued their craft in a normal way at the same clay beds they knew how to use. But methods of potmaking do travel. When the Khalifs brought the sugar cul-

ture to Palestine and Egypt they imported the
complete know-how, including the method of pot-
making that went with it from the East. There are
two types of sugar pots; a sugar mould and a sir-
up (?) pot, and they could easily have been made
in the traditional methods of potmaking found lo-
cally in Palestine, but they never were. This
foreign method spread over all the sugar producing
areas in the Eastern Mediterranean countries
(Franken, 1974).

Apart from the methods of potbuilding sometimes
other indications can be found that potters came
at some time in the past from a different locali-
ty. Adding non-plastic or organic materials to
the clay in order to reduce plasticity of the clay
is a method already found in what seems to have
been experimental stages of Neolithic pottery from
Jericho. If a temper is found in a paste that is
already rather lean by nature, like quartz sand
added to some clays in the Tabqa area of the
Euphrates, or, what is worse, calcite, lime or
chalk, we clearly see that psychological law at
work that a potter has to do what his father did,
even if it is totally unnecessary. But the 'fore-
fathers' learned to do it because they worked with
clays too plastic for the method they applied.
And so we can assume that the tradition migrated.
This case is different from that of the Iron I
cooking pots from Palestine that contain very
coarse calcite. This is a special type of pot
made according to a centuries old recipe and cal-
cite was either collected by the potters or traded.

The time that ethnic tradition was considered
as unchangeable is long past. Potters' traditions
may belong to the most conservative groups of tra-
ditions but changes must have occurred. Traditions
may influence each other, or live side by side as
the Arabic sugar pots show, new techniques are
developed, probably under the pressure of the need
to speed up production, or the demands of a power-
ful high level class of soldiers occupying the
territory.

It seems likely that the Assyrians introduced
throwing as a technique in Palestine which revolu-
tionized the pottery industry during the 7th-6th
centuries B.C. But nevertheless there are rela-
tions, contacts, influences. Our traditional
method of shape typology is not equipped to trace
these streams of tradition, to follow them and to
map them up- and downstream. The basic mistake is
really that pottery is mainly studied for its
value as a time indicator and cultural mark. It
is not studied for the purpose of understanding
pottery itself, its history, its tradition, its
technological level, its function in the society
and the people who made it and used it. Therefore
that method will not enable us to test its re-
sults. It is only tested for things for which it
was not made: to indicate time or culture. We
have to study pottery for its own sake in order to
find out what it can do for us. And so we need to
analyze ancient pottery to the very core.

The subject of this new Series is the techno-
logical analysis of pottery from excavations.
This technological analysis promotes primarily
our understanding of the potter's craft. Slowly a
picture emerges of a potter at work. We identify
some of the tools he used, we learn to know some
of the problems he was trying to solve, how in-
ventive he was, the rate at which he produced the
different types which reflects the needs of his
customers and many other aspects of his trade. At
the same time we obtain a method of testing the
reliability of pottery typologies and we learn to
judge what can reasonably be deduced from pottery
as a time indicator. In our present experience
with this new method more often than not pottery
groups have more to tell than the archaeologist
suspected. And as the questions asked by the
archaeologist were not always appropriate to the
material we have missed a good deal of very use-
ful archaeological information about the societies
for which pottery was produced.

The Netherlands Organization for the Advancement of Pure Research (Z.W.O.) at The Hague has financed my researches in practical and theoretical studies in pottery typology since 1960, including five seasons of excavations at tell Deir ͨAllā, Jordan. Since 1972 the same Organization is financing three seasons of excavations in the Tabqa area in the Euphrates Valley, North Syria. This project aims at collecting large samples of pottery groups from a limited geographical area but from different cultural periods. The objective is the study of the influence of clay paste composition on potmaking methods and the methods of improvement of the clay paste used by the potters to adapt the properties of the paste to their needs. The reports that will be published in this Series, North-Holland Ceramic Studies in Archaeology, are all based on this type of analysis and will illustrate various aspects and possibilities of this method.

Balfet, Hélène, 1966. Ethnographical Observations
 in North Africa and Archaeological Inter-
 pretation: the Pottery of the Maghreb,
 p.161. Ed. F.R. Matson, Ceramics and
 Man; London

Binford, Lewis R., 1972. An Archaeological Per-
 spective, p.252; New York and London

Clarke, David L., 1968. Analytical Archaeology,
 Part 1, 5; London

Ericson, Jonathon E. & Gary Stickel, E., 1973.
 A Proposed Classification System for
 Ceramics, p.356 ff. World Archaeology
 Vol.4

Franken, Henk J. & Kalsbeek, J., 1969. Excavations
 at Tell Deir ᶜAllā, I, pp.102-104; Leiden

Franken, Henk J. & Power, W.J.A., 1970. Glueck's
 'Explorations in Eastern Palestine' in
 the Light of Recent Evidence, p.123.
 Vetus Testamentum Vol.XXI

Franken, Henk J., 1974. Excavations at Tell Deir
 ᶜAllā - The Medieval Tell and Cemetery:
 Tell Abu Gourdan, Ch.VII. Ed. Department
 of Antiquities; Amman

Martin, Marshall E., 1974. Tell Deir ᶜAllā, Iron
 Age II. Ph.D. Thesis; Leiden

Matson, Frederick R., 1960. The Quantitative
 Study of Ceramic Materials, p.44; in
 R.F. Heizer & S.F. Cook, The Application
 of Quantitative Methods in Archaeology;
 Chicago

Morgan, Charles G., 1973. Archaeology and
 Explanation, p.273. World Archaeology
 Vol.4

Smith, Robert H., 1970. An Approach to the
 Drawing of Pottery and Small Finds for
 Excavation Reports, p.215. World
 Archaeology Vol.2

Watson, Patty J., LeBlanc, Steven A. & Redman,
 Charles L., 1971. Explanation in
 Archaeology (1), p.121; (2), Ch. 5;
 New York and London

Part One

IN SEARCH OF THE POTTER'S CRAFT

IN THE IRON AGE

AT JERICHO

With a Note on the Stratigraphy
By Dr. K.M. Kenyon

PREFACE

 The Iron Age pottery excavated in trench 1 at
tell es-Sultan, ancient Jericho, by an expedition
of the British School of Archaeology in Jerusalem
under the direction of Dr. K.M. Kenyon, was col-
lected during the seasons 1952-1953 (Kenyon,
1952). Various members of the excavating team did
the preliminary recording during these seasons.
In 1957 I asked permission from Dr. Kenyon to pre-
pare this pottery for publication, and consequent-
ly it was shipped off to the University of Leiden.
Almost fifteen years elapsed before this report
was produced. I owe the Director of the excava-
tions and my colleagues in the field an explana-
tion for this delay.
 As I recall it now, I saw an opportunity to get
firsthand knowledge of Iron Age pottery from the
7th century B.C. from Palestine. I started work-
ing on the pottery as soon as it had arrived and
it should have been easy to make a typology since
so many similar groups of pottery had already been
published. I wrote the report not once but four
times having drawn all the sherds and described
every feature in the accepted way. I had all the
parallels lined up, up to date, and the report
seemed to be ready for publication each time I had
worked through the material again. But each time
I repeated the exercise my doubts about the pro-
cedure and the results became stronger. It is,
of course, difficult now to formulate exactly what
the doubts about the procedure were. Basically it
was a problem of verification. Not having been
educated in an archaeological Institute I was
wondering why colors of pottery were so different.
One can buy thousands of bisquit fired flower pots
and they all have the same color. From the dif-
ferent descriptions in the archaeological publi-
cations I could not really figure out what 'well
levigated' was. Did it simply mean that there
were no visible impurities in the clay? The worst
thing however was that no two sherds had exactly

the same profile; and, if they did, the question
arose, could they have belonged to one pot? In
other words, how many types was I supposed to
make? Whatever I tried, the amount of types al-
ways seemed to grow beyond reason. If potters in
antiquity cared so little about uniformity of rim
shape, would they always have been careful to build
a pot underneath the rim which could be paralleled
to complete shapes as published from other sites?

When I had the opportunity to start on my own
excavation at tell Deir [c]Alla in 1960, this Iron
Age pottery and the report were left untended be-
cause I wanted to find an answer to these and simi-
lar questions. The work done by J.L. Kelso and
J. Palin Thorly (Kelso, 1943) seemed to me to pro-
vide a clue as to where to look for solutions.
I now think that had their work found the recogni-
tion it deserves, the face of archaeology would be
different from what it is today.

After the first season at Deir [c]Alla I was again
faced with the problem of verification of typology
which to my mind should be solved in the same way
as the problem of stratigraphy had been solved in
the Palestinian field by Dr. Kenyon (Kenyon, 1942).
The governing board of the University of Leiden
agreed at my request that I should work in co-
operation with a professional potter. I was fortu-
nate in those years to find Mr. J. Kalsbeek, who
showed broad interest in socalled primitive pottery
and was willing to start work on the pottery from
tell Deir [c]Alla. The 'historical moment' came
after many months, when Kalsbeek had seen and drawn
every single sherd there was, and had come to the
conclusion that my rather innocent remark that the
pottery was wheel-made, was completely mistaken.
After that he started to build a different and
highly complicated picture of the potter's work
which resulted in my destroying another report on
typology of pottery. The first results of our
combined struggle were published in 1969 (Franken
& Kalsbeek).

In 1971 I started again on the typology of the

Jericho pottery. The drawings of the pottery
shapes from each phase became an appendix. I used
the experience from the study of other pottery
groups, which were presented to us by archaeolo-
gists working in Western Europe and Africa for the
introductions to various features found in this
report, and which constitute the main body of it.
I have argued in this report for the necessity of
giving shape - or 'appearance' - typologies a more
scientific basis. This can be done by an analysis
of the ancient potter's methods of potmaking,
which starts with research into the collecting of
the raw materials and ends with the firing and
marketing methods. Up to a certain point at least
this research can be supported by experiments in
which theories are tested. Typologies based on
this type of research can be controlled by statis-
tical means and the reliability of statements can
be controlled. Clearly, this causes a shift in
focus in the traditional way of studying and pub-
lishing pottery. This report also argues that it
is necessary to rethink the validity of compara-
tive studies of individual pieces of pottery as
far as they are not based on an analysis of the
potter's work in its totality: all the daily ac-
tivities in the potter's workshop.

It is not possible to lay down in this report
the whole framework of a systematic approach to
the study of pottery as it has been developed aft-
er more than ten years of intensive research in
Leiden (Franken, 1971). In the last few years
several Dutch archaeologists working in the field
of prehistory and medieval archaeology have joined
this attempt to a systematic approach and begun to
contribute to it. This approach makes it necessa-
ry to reformulate the requirements of sampling
from excavated pottery. The Iron Age sherd col-
lection does not quite permit a study as I now
think should be performed as standard procedure.
Aside from this limitation it seems necessary to
experiment with clays found near ^cAin es-Sultan
and on the tell itself because it would certainly

give better understanding of the potter's craft in
all the cultural periods represented on the tell
and lead to more accurate statements about the
typology.

Some readers may now think that the typology
offered here has been over-simplified since they
can recognize the pot shapes that belong to a cer-
tain rim type, analogous to complete shapes found
elsewhere. At this stage of my researches I can-
not agree with this procedure. In our system it
becomes possible to predict which pot shapes the
potters could have made within the limits of their
traditional and practical knowledge of the craft.
This range of possible shapes can be reconstructed
from the knowledge of the type of clay used, the
method of mixing it, of building the pots, and of
drying and firing in the kiln. It is also possi-
ble now to a large extent to say what could not be
made within the limits of this whole system. The
range of possibilities is usually much larger than
what the actual production included. But, what
shapes were made can only be known in an empirical
way, not by analogy from findings at other centers
of production or marketing. It is not only danger-
ous to rely on analogies, but it hampers progress
of our knowledge if we continue to fit at all
costs the unknown into the known. As long as one
does not recognize the necessity of a scientific
approach to pottery studies, we make refinements
in the known typological arrangement of the ce-
ramic picture in Palestine and continue to over-
look the possibilities of distinguishing pottery
producing centers from markets, or, in the case of
the pottery from tell es-Sultan, to single out
those pots brought to the site from across the
Jordan, or from elsewhere in Palestine. In both
cases a careful analysis of the temper and micro-
scopic characteristics of the fired clay body are
necessary to detect these foreign pots in the
Jericho group. In the collection of Deir 'Allā
pottery from the same period complete shapes from
the tell are comparatively abundant and there it

can be seen that shape analysis is not enough to
detect the 'strangers', because they come from the
same cultural background. But once the fired clay
body and the nature of the temper have been ana-
lyzed one can build the argument along various
lines: Where is this type of rock found that was
used for temper? Do we have to assume that pot-
ters suddenly changed the traditional recipe for
the clay mixture? If so, what was the reason for
the change? Or does the material indicate another
place of production, or was there a totally new
method of pottery production? Where was it lo-
cated and where did it come from?
Cases of all these possibilities are found in this
report. After all, it is only natural that at a
border site like Jericho, situated near a ford of
the Jordan, pottery is found which was not locally
produced but traded or left behind by visitors of
the site.

Provided there are enough complete pottery
shapes or sherds to indicate the construction of
those shapes, one can summarize the potmaking
techniques in one model, which explains all the
shapes found (Franken, 1974). We have already
often found in our study of large groups of sherds
from different places and cultures that pots with
a different tempering material cannot be explained
from the same model. Not only is the Middle
Bronze Age cooking pot foreign to the model which
explains the ordinary household pottery, but the
Iron Age I cooking pot is also a total stranger
when compared with the model of the other types.
This pot cannot have been fired together with
other types in the kiln for technical reasons; its
origin lies not in Palestine; its shape develop-
ment is behind that of other types, etc. This
report contains some of the elements from which a
model can be constructed. There is however not
enough material to make such models for the pots
which were not locally made.

After I had sent this final report to Dr.
Kenyon she made the point of the physical impossi-

bility of keeping every sherd on a large dig. This
is of course true. I have been fortunate in that
the Netherlands Organization for the Advancement
of Pure Research accepted not only to finance my
excavations but also provided the funds and the
personnel for the development of this new approach
so that I could take home as much pottery as I
needed from Jordan. From the excavations in the
Tabqa region we brought back to Holland every
sherd found. But this is the experimental stage.
During excavation time was too short to make ex-
periments in sampling and since criteria for
sampling should be worked out and will be reported
on, we had to follow this costly procedure, much
to the astonishment of Department and Customs
officials in all countries involved. However,
even though this present sample is not quite what
I should like to have, there is no damage done.
By no means. The experiment can be repeated one
day.

I gladly testify my indebtedness to Dr. K.M.
Kenyon, who not only taught me archaeology in the
field the hard way but also introduced me to the
study of pottery on the dighouse pottery mats near
ᶜAin es-Sultan. She seemed somewhat relieved that
somebody volunteered to study the Iron Age materi-
al and to prepare it for publication. She agreed
'very readily' that I should publish this report
in advance of Jericho III. I am extremely thank-
ful to have her consent in this matter.

I am convinced that pottery studies in the
future will be based on principles like the ones
that have been laid down in this report. I am
equally convinced that the solidness which tran-
spires through the studies of Dr. Kenyon cannot be
acquired by simply using testing equipment and
bringing out some new ideas produced as a result
of the manipulation of these tools. If I had the
mastership of the art on archaeological study of
pottery of Dr. Kenyon, this report would have been
of better quality. Yet it is only natural that
the possibilities of research offered by modern

ceramic sciences be explored.

Mr. Kalsbeek has made many valuable remarks on
the structure of the pottery and generally I have
profited from his knowledge. Dr. Kenyon made a
number of useful remarks. Albert Jan Cool made
the drawings; Marshall E. Martin read the English
manuscript and corrected my mistakes.

Note
The division of the sherds in phases that was
used while this report was written, was based on a
provisional list of the stratigraphical sequence
of the deposits, made in 1955. In the final ana-
lysis by Dr. Kenyon it was found that some of
these phases should be combined to one phase.
With the exception of Sections 7 and 26, Charts
7,8 and 9, and the numbers of the published sherds
I have brought this report in agreement with the
final list of phases. It was not necessary to
rewrite the statistics in the sections mentioned
above for the sake of the argument. This made it
necessary however to add the earlier phase numbers
to the present list (see Section 60).

1. INTRODUCTION

The following study of the Iron Age pottery
from Jericho combines an analytical study of the
potter's manufacturing methods with a shape ana-
lysis.

Shape analysis in typological studies of exca-
vated pottery concentrates on the finishing treat-
ment which was given to the rims. This finishing
treatment has to be considered a routine manufac-
turing process, which was traditionally determined
and carefully preserved by the potters. This re-
sults to some degree in standardization of rim
shapes. The implications of this conception will
be discussed below.

The study of the potter's manufacturing methods
was somewhat hampered by the lack of bases and
wall fragments. However, in general there was
enough material to make the following sketchy re-
construction of the craft.

> The author wishes to state emphatically that
> this is not meant to be a criticism of the
> selection of sherds made at the excavation.
> This collection of Iron Age sherds from Jericho
> was given to the present author in 1957; it was
> agreed that a typology would be made based on
> shape analysis. This was entirely in agreement
> with the advanced archaeological thinking of
> the day, as witnessed by the fact that no pre-
> liminary selection of rims was applied.
> Every stratified rim sherd and all other frag-
> ments that were considered to have diagnostic
> value were kept, including those that might
> have been considered as being earlier than the
> main body of sherds.

2. THE RAW MATERIALS

It can be taken for granted that most of the
pottery was locally made. The reason for assert-
ing this is given in the section on thin-slides

and tempering materials (Sections 8 and 9), where
it is stated that the clay used by the Iron Age
potters has a high content of carbonate very fine-
ly distributed in the clay. This would cause the
clay to lose some of its plasticity and to re-
quire more water when worked. Furthermore the
non-plastic materials added in preparing the clay
consist of rock characteristic of the Judean
mountains: fossiliferous chalk, chert, and cal-
cite.

There is a difference between the tempering
materials used in the Jericho pottery and those
used in the Iron Age I. The size of these non-
plastics is more or less controlled, probably with
the use of a sieve. Normally it would be called
'fine grit'. For the size of the grit, see sec-
tions 9-15.

What clearly distinguishes this clay mixture
from the pottery of Transjordan, and probably from
the ware of Palestinian sites near the coast, in
the south, and in the north, is the absence of
quartz and basalt. The high content of carbonate
prohibits firing temperatures exceeding ca. 850°-
900° (see Section 18); it also makes the sherd
porous. This mixture has a good adhesive quality.
Coils and handles adhere very well, and the pot
does not break at the joints.

Two other elements which influence the appear-
ance of the sherd can be discovered. One is salt,
which may partly at least have been in the clay or
have been added by the potters. When the modeling
of the pot is finished and it is put away to dry,
salts come to the surface of the pot and are de-
posited there by the evaporating water. When
fired, these salts fuse chemically with the fumes
of the fire forming 'scum' or 'bloom' on the sur-
face of the pot. This scum must be distinguished
from slip. Scum gives a red-firing sherd a light-
er appearance. Where dry-scraping is practiced
before the pot is fired, most of the salts can be
removed in the process. The scraped part is more
red than the non-scraped part after firing.

The other element is secondary lime, which has the
same effect of blurring the color of the surface.
While the sherd is buried in the soil, lime from
the clay is deposited by ground-water on the sur-
face of the sherd. It also penetrates hair cracks
and holes. It seems that some sherds are more
susceptible to this secondary lime deposit than
others, the reason of which is not yet clear.

3. MANUFACTURING METHODS

The manufacturing methods of the Jericho pot-
ters belong to the tradition of the Iron Age I,
but they were, so to speak, preparing the way for
the use of a fast wheel. This pottery is called
wheel-made, but the expression needs some quali-
fication. In English (not in every other lan-
guage) there is in the potter's vocabulary a dis-
tinction between turning and throwing. Throwing
requires a wheel which gains momentum when set in
motion and continues turning for some time after
one stops kicking or pushing it. Turning on the
other hand refers to a wheel which does not need
this quality, nor does it necessarily indicate a
wheel. Generally it refers to a base which can be
rotated by hand, and which turns as long as one
pushes it. A round base from a broken jar set in
mud can be used for this purpose. The Jericho
potters almost certainly had a better device.
Most of the Jericho Iron Age pottery is turned
and not thrown. In outline the methods employed
are as follows.
a. Small pots (juglets, small bowls, lamps) were
 made from one lump of clay and probably more
 than one were shaped out of one lump (from the
 cone). In this case one might speak of throw-
 ing except for the fact that in every case the
 potter reworked the shape after it had been
 taken from the turning base.
 Juglets.
 The round base was reshaped on the outside by

smoothing it with the hand or with leather or
cloth.
Small bowls.
The rim was smoothed by leather or cloth. Then
the rough shape was put aside to dry the rim.
When the rim was leather-hard and before the
base was dry, the shape was put back on the
wheel. Then the surplus clay around the base
was scraped away with a rib and the base was
given its shape. The rib is a potter's tool
used to shave away the surplus clay from a
pot after the rough shape has been completed,
or while the pot is still being turned on the
wheel. In the Iron Age in Palestine such a
tool was in common use and when found on a
site it can be taken as an indication of a
local pottery workshop. The tool is not al-
ways recognized by the excavators. The
'feluccas' from Megiddo, Tombs, p.17, Pl.158,
1,4 and 18 are ribs made of pottery. The
crescent shape with a hole for the finger,
which is in use in Palestine at present, has
not been found at Deir ᶜAllā.
A practically complete shape with inscription
in an unknown script from Deir ᶜAllā has been
published (Franken, 1968). This rib was spe-
cially made for the purpose and it had been
used, as witnessed by the marks of wear on
both long sides.
Often a sherd was reshaped by the potters in
which case there is no hole for the finger.
The shape is fairly characteristic and the
traces of its use are clearly visible on pot-
tery. When used on the inside of pointed jars
the tool marks stop somewhere above the base.
The tool is too large to reach the bottom.
Inside bowls the rib can be used near the base.
The use of the rib can be studied on pottery
itself. It is important to collect data of
findspots of ribs in order to trace pottery
making centers.

Lamps.
The rim was dried. Then the base was reshaped
with a rib or by hand while the lamp was held
in the hand.
b. Larger bowls with profiled rims were built in
 coils. The rims were folded. Then the rim was
 allowed to dry and the pot was put back on the
 wheel upside down. The base was then shaped by
 scraping away the surplus clay with a rib, fol-
 lowed by hand smoothing.
c. Larger jars were also built in coils. There
 were two methods, and the distiction probably
 refers to jars with flat bases or with round
 bases.
 Flat bases.
 The potter began with the base and finished
 with the rim. Some reshaping near the base on
 the outside by scraping was often necessary to
 thin the wall near the base.
 Round bases.
 The potter built the jar from coils, then he
 cut the shape from the clay on the turning base
 in such a way that the shape was open (cut
 through the wall). Then he allowed the shape
 to dry, put it back upside down, and closed the
 base by adding one or more coils and turning.
 Sometimes one finds that this method was also
 used on small juglets (dippers) where no coil
 needed to be added and the base was closed in
 a turning movement.

4. THE ROUTINE OF POTMAKING

The majority of the material is made in this
tradition which really is a continuation of the
Early Iron Age tradition in Palestine. All the
profiled rims are folded in this method. But some
pottery is thrown. This could be established for
certain on some cooking pots and it is suspected
that some small and large jars were also thrown.
Large jars, though thrown on a fast wheel, were

often made in sections, that is, two sections were
separately thrown and then luted together, or the
upper half was first thrown, turned upside down
and the base thrown closed. The material avail-
able does not permit hard and fast conclusions.

In the discussion of the types more details
will be given about the methods used by the pot-
ters. The assumption is that the potters not only
made each type of pot according to the inherited
craft but also finished the rims with routine
treatments. These routine treatments were influ-
enced by two factors.

a. One is the amount of surplus clay at the rim.
It is perfectly clear that sometimes the potter
did not have enough clay in the last coil to
finish the rim properly. The rim in this case
is shorter or thinner than usual. Sometimes he
found a stone in the last coil, and instead of
taking the stone out he folded the rim at that
height. If there is a large stone, it is al-
ways in the fold of the rim and in pots whose
necks are often shorter than usual.

b. More important however is that in the long run
these routine treatments changed and the rim
profile became different. These changes in-
fluence not only the rim but the whole shape
of the pot. These slow changes in the tradi-
tion are the only elements from which time can
be deduced. Therefore one has to trace these
developments by studying the tendencies toward
change in the craft itself. Some of the impli-
cations are discussed below.
Understandably as long as the same methods are
basically employed, rims sometimes turn up that
look either too late or too early for the con-
text in which they are found. Examples will be
found in this report.

5. TENDENCIES OF DEVELOPMENT

In order to trace such tendencies at work in

the craft during the period under study four as-
pects have been highlighted.
a. Apart from the surveys of types found in the
 entire group a survey of pottery shapes has
 been made for each level (see Figs. 7-19). This
 is one means of finding out whether there was
 any development. The restrictions imposed on
 this method are discussed in Section 7.
b. A chart of the use of slip has been made to see
 if there is any change in the course of time
 (see Chart 9).
 Slip is a layer of fine clay painted on the un-
 fired pot. When made of the same clay as the
 pot it is not mixed with tempering materials;
 therefore the color of the slip is darker than
 the pot itself in the Jericho pottery. When
 made of a white-firing clay the color of the
 slip is influenced by the fact that it is mixed
 slightly with the surface clay of the pot. A
 brush was used to apply a slip. Dipping as a
 method of application has not been observed.
 The color of the slip is obscured in two ways.
 By formation of scum and by secondary lime
 deposits (see Section 2). Some sherds revealed
 a slip layer only after they had been refired.
 The Iron Age potters had a good recipe for the
 slip as evidenced by the fact that it did not
 flake off. Slip was often applied to make a
 rough surface (rough from treating the pot with
 a rib) smooth.
c. A chart for the practice of burnishing has been
 drawn up. Often burnishing and slip go to-
 gether (see Chart 9).
 Burnishing has the same purpose as a slip layer
 and, as a rule, is only found on hand-made pot-
 tery. Throwing is only invented to speed up
 the production and burnishing is a very labori-
 ous process. There is no such thing as 'wheel-
 burnishing' in the sense of burnishing a pot on
 a fast wheel.
 After a nearly dry wall has been thinned with a
 rib, the surface shows the scars of the treat-

ment as grit is moved over the new surface.
These grooves cannot be smoothed with a wet
cloth because the wet cloth would take away
more clay and bring more grit to the surface.
A rib has to be used to press the grit down in-
to the wet clay body. Sometimes this has a
burnishing effect. Depending on the degree of
dryness and on firing temperature the result
will be a shiny surface. Large bowls were
dryer near the rim than near the base, and con-
sequently the sheen is better preserved near
the rim. How rough the surface was before
burnishing can often be observed on large frag-
ments of 'ring-burnished' bowls where the
strokes are widely spaced (near the base inside
the pot). Absence of sheen does not always
mean that a pot was not burnished. One has to
look for the impression of the burnishing tool.
d. In Sections 8-17 on the tempering materials it
is suggested that some pottery contains grit
which has been sieved. This could be closely
related to quicker turning or throwing. The
ratio between coarse and fine grit has also
been worked out in a chart (see Charts 7 and 8).

6. THE CLASSIFICATION OF RIM SHAPES

Rims were not made horizontal at the top with a
cutting needle, as is done in throwing, but by
folding the surplus clay down on the inside and
smoothing it out against the inside of the neck.
The reason is that coarse grit in the clay makes
it impossible to cut the clay with a needle; so
uneven thickness (the overlap in the coil from
which the neck and rim were made) could only be
disposed of by pulling the clay up, followed by
smoothing it out and folding the top half of the
rim back into the pot. While doing this the pot-
ters made a 'hollow' just before the fold. This
can still be seen in this period on some cooking
pots and jars. The clay which was folded back may

accentuate the hollow or fill it up. In the latter
instance the fold is only visible in thin section.
Such was the basic treatment. This treatment is
clearly observable on the pottery at the moment
when this tradition of potmaking enters Palestine
in the beginning of the 12th century B.C. or
slightly earlier. It is still found at the end
when this tradition is gradually eclipsed by a
technique of throwing, apparently in the 7th cen-
tury B.C., as the Jericho material shows.

Having made the fold, the potter then gave the
rim its characteristic shape, the traditional rim
shape which belonged to each type, by various
manipulations. This may have been pulling the rim
up again, pushing the top of the fold down, or
turning the whole rim into a vertical stance etc.

What matters in the typology is (a) the fact
that, given a sufficient amount of pottery from
one type and one level, it is possible to find the
standard type and the variations, each of which go
back to the routine position of the potter's
fingers when reshaping the rims; (b) given a suf-
ficient amount of sherds, divided over a number of
phases, one can trace the changes in the position
of the potter's fingers over a long period and
thus the tendencies at work in the tradition can
be discovered.

Furthermore from complete shapes one can study
the improvements in turning (from slow to quicker
turning), and subsequent improvement, closely re-
lated to the improvement of the wheel: the size of
the tempering material which becomes smaller, as
much more attention is paid to the preparation of
the clay so that no large bits of stone or other
impurities are left in the clay. Large bits, the
size of the width of a thin wall, are occasionally
found in turned pottery but not in thrown pottery.
This can be observed in the Jericho repertoire.

Lists were made indicating the phases in which
the types and variants occurred. In doing this
the groups were broken up into small groups.
This poses an important question. How reliable is

the statistical evidence thus obtained?

7. THE RELIABILITY OF THE TYPOLOGY

When taken individually, none of the phases
have produced anything like the amount of pottery
necessary to trace the dominant variations, the
appearance of new ones and the dying out of old
ones. Nor is there enough pottery to determine
the ratio of the variants or the ratio of the dif-
ferent types to each other through the phases.
The amount of uncertainty can somewhat be esti-
mated from the following Tables. As we have no
other example of this type of checking the relia-
bility of a typology, we have taken the evidence
from the experiment on the Deir cAllā pottery as a
standard of measurement. A minimum of 300 sherds
from one phase gives a reliable ratio for the
various types (Franken & Kalsbeek, 1969 (1)).

We have grouped the Jericho material as fol-
lows: phases 24-17 (1); 16-10 (2); and 9-5 (3).
With the exception of the really rare types, the
total amount of three groups of pots: cooking pots
bowls and jars, have been counted for each of the
three groups of phases. We find the following
totals and percentages.

	Cooking Pots	Bowls	Jars	Total
(1)	54=28.5%	98=51.8%	37=19.5%	189
(2)	129=21.9%	314=53.3%	146=24.8%	589
(3)	27=17.0%	88=55.7%	43=27.3%	158
	210	500	226	936

It seems reasonable to suppose that the second
combination of phases comes close to the ratio
existing in that period, whereas the two other
groups are less reliable. At the same time it can
easily be seen that each individual phase is less
reliable. For the phases 11 and 10 we find the
following.

	Cooking Pots	Bowls	Jars	Total
(1)	28=16.2%	89=51.4%	56=32.3%	173
(2)	24=18.3%	89=67.9%	18=13.7%	131

What this means in practice can be illustrated as follows. In the group cooking pots, type 1 is an early shape, closely related to Fig.3,1, on its way out. It was found sixteen times from phases 24 to 11 and not afterwards. The fact that it was not found in phases 10-5 does not prove that it was not longer made after phase 11. We cannot fix the end of it from the existing evidence. (Neither can we fix the end of this type in the Jericho repertoire by comparison with other sites, unless we can demonstrate that Jericho and the other sites obtained their pottery from the same market (see Section 21).) Our theory that, in periods undisturbed by major events, a certain ratio of pottery types can be found, which may change over a long period of time and be different for different cultures, is based on the statistical evidence from the Deir cAllā excavation and on the consideration that in a normal community where pottery is in daily use, there is a fixed pattern of replacement of broken pottery when taken over periods of something like ten years. The potter's production program was adapted to this (in the long run regular) demand. And the kiln very closely regulated the output in time and in amount.

This method of studying pottery is so designed to trace as closely as possible the tendencies of shape development by a study of the changing methods of the potters, and to demonstrate the reliability of a sample as to representativeness of a repertoire.

8. THIN-SLIDES ANALYSIS - the raw materials

This Section of the study is based on the analysis of 45 thin-slides.

The clay used by the potters reveals some impor-
tant characteristics. The clay is more or less
silty. Fine quartz grains (<0.01mm.) are found in
quantities from several per 0.25mm^2. to 1 or 2 per
mm^2. Some form of iron (hematite) is always pre-
sent in fine grains (<0.05mm.), not more than 1 or
2 per mm^2.; sporadically one finds a grain of
<0.25mm. (less than 1 per cm^2.).
Chert is also always present in grains of <0.25
mm., not rounded (less than 1 per cm^2.).
This clay always contains a high percentage of
carbonate derived from fossiliforous chalk evenly
mixed with the clay, and frequently many washed
out microfossils (shells), often more than 5 per
0.25mm^2. It is very likely that this clay was
dug from beds belonging to the Lisan formation in
the Jordan Valley near Jericho (Ricard & Golani,
1965).

These features are common to most sherds exam-
ined. The few exceptions will be discussed below.
The picture is the same as the one which resulted
from a study of 100 thin-slides taken from sherds
of the Jericho pottery Neolithic A and B groups.
This picture differs significantly from the char-
acteristics of the Deir cAllā clay (Franken, 1974
(1)).

9. THE TEMPERING MATERIALS AND TEXTURE

The tempering materials consist of non-plastics
that are found in the mountains to the west of
Jericho: fossiliforous chalk and calcite; and
rarely rounded grains of chert. Quartz is almost
absent; basalt is not found at all. This was also
the case in the Neolithic sherds.
These tempering materials can be divided into six
groups.
a. Calcite, mostly $<0,25$ mm. to very small,
 <0.01mm.
b. Calcite, always <0.05mm.
c. A mixture of chalk and calcite grains, mostly

<0.25mm.
d. Sand: quartz and chert in rounded grains,
 <0.1mm. (rare)
e. Chalk grains, mostly <0.25mm. to very small
f. Quartz, <0.05mm. in large quantities.
 With these non-plastics one finds occasionally
grains of pounded pottery (grog), large shell
fragments, and rounded grains of chert, but no
other impurities. Undissolved clay grains are
rare.
 The standard procedure for indicating grain
size is as follows.

Texture	Diameter of grains in mm.
Very fine	0.05 - 0.1
Fine	0.1 - 0.25
Medium	0.25 - 0.5
Coarse	0.5 - 1.0
Very coarse	1 and above

 It must be pointed out that the use of a stand-
ard scale is of limited value for understanding
the importance of type of temper and other non-
plastic impurities for the clay paste. The temper
that was added by the potters may be 'medium' but
the matrix may contain other impurities like bits
of chalk, grog, grains of clay that were not bro-
ken up when the clay was mixed with water, etc.,
all in small amounts that are 'very coarse'.
Moreover the amount of temper added plays an im-
portant role in the manufacturing process. There
is a tremendous difference between the use of
quartz and basalt or carbonates. If the average
size is 'fine' but there is one 'medium' grain per
mm^2., then the clay paste cannot be used for
throwing, etc.
 Matson has analyzed clay pastes and temper of
different pottery groups in the Near East, but he
relates the results to the existing typologies.
Here an attempt is made not only to make distinc-
tions in clay sources, origin of minerals etc.,
but also to relate the nature, sizes and quanti-

ties of the non-plastic temper and óther impuri-
ties to the manufacturing methods, including the
firing of the pottery. In modern ceramic techno-
logy these aspects play a dominant role in the
production of pottery for specific purposes.
Size and amount of tempering materials (non-
plastics) are strictly controlled and related to
the function of the pot.

10. THE RELATION TEMPER - POTTERY TYPES

With the exception of f. all the tempering
materials can be seen with the naked eye.
Occasionally a sherd from a.-e. seems to have no
temper, in which case it has not been fired above
ca. 650°, and for a short time only. When fired
until the core is red, the grit shows up, as wit-
nessed in some firing tests (see Section 19).
One group of bowls has no temper (see Section 13).
It is often not possible to distinguish calcite
from chalk with the naked eye due to the fact that
calcite often recrystallized during firing and
lost its shiny surface. As a rule 'shiny grit'
in this Jericho repertoire is calcite, not quartz.
Examination of the thin-slides made it possible
to classify most sherds with the aid of a magni-
fying glass without taking more thin-slide
samples.
In pottery studies in Palestine little atten-
tion has been given to the relationship of the
nature of tempers used by the potters and the
types of pottery in which it was used. The 45
thin-slides used for this analysis are not suf-
ficiently representative of the repertoire to
make this study definitive. However, they are
sufficient to demonstrate that typology is de-
pendent on such an analysis. The use of different
materials, quantities and grit size (texture),
have far-reaching consequences for the methods of
potmaking and for the 'appearance' of the final
product. It can be demonstrated that very often

temper but not shape is indicative for a different
origin of certain types. In the case of the
Jericho pottery as in many other groups that have
been studied in this way the study of temper
groups aids in detecting the composite nature of a
repertoire. In fact examination of the tempering
materials shows that ceramic history is often more
complicated than is and has been assumed.

11. COOKING POTS

It is not surprising to find that, with the ex-
ception of thrown pots, calcite is the temper of
the cooking pots, since we know that it is the on-
ly temper in the cooking pots of the Iron Age I.
Calcite is known to reduce shrinkage. It occurs
in veins of the chalk of the Judean mountains. It
was used sometimes by the Neolithic potters from
Jericho and is found in the hand-made cooking pot
from El-Gib made less than ten years ago.
The El-Gib cooking pot stems from a Medieval pot
tempered with calcite (Franken, 1974 (2)). The
Early Medieval cooking pot, however, which comes
from the Byzantine tradition, contains quartz
temper; the first cooking pot with fine quartz
temper in the Jericho repertoire turns up with the
thrown pots. The hand-made cooking pots all have
a calcite temper.
The calcite occurs mostly in grains of <0.25mm.
to very small, with occasionally larger grains of
<1mm. The density is for the most part 10 grains
per 0.5cm^2. but can be as much as 20 grains per
0.5cm^2.
The exceptions are
a. Cooking pot, type 6 (see Section 27).
 Classified as a Transjordanian shape. One
 thin-slide examined. It is a carbonate clay
 mixture, the temper is rounded quartz and flint
 grains <0.5mm. with a density of ca. 10 grains
 per 0.25cm^2.
b. Cooking pot, type 8 (see Section 28).

Classified as wheel-thrown. It is made of a
carbonate clay mixture, tempered with very fine
quartz, <0.01mm. in large quantities.
c. Cooking pot, type 9 (see Section 28).
Classified with the thrown cooking pots. One
thin-slide examined. The clay is a carbonate
clay mixture, tempered with very fine quartz,
<0.01mm. in large quantities.
d. Cooking pot, type 10 (see Section 28).
Classified with the thrown cooking pots. The
clay is a carbonate clay mixture, tempered with
calcite pounded to very small grains, <0.05mm.
with a density of ca. 4 grains per $0.25mm^2$.
e. Cooking pot, type 12 (see Section 28).
Classified with the thrown cooking pots. One
thin-slide was examined. No carbonate is in
the clay. The temper is very fine quartz,
<0.01mm. in high concentration, more than 10
grains per $0.25mm^2$.

In total fourteen cooking pot sherds were
examined. Five, suspected not to have the common
background of the Iron Age I, are all deviated
from the normal pattern with respect to their
tempering materials. The Transjordanian cooking
pot, type 6, has quartz and is comparable to the
common temper from Deir cAllā.

Of the thrown cooking pots, type 10 contains
calcite, and it is the only ware containing cal-
cite in extremely fine fraction. Obviously a
sieve was used. The others break completely with
the old tradition and contain very fine quartz,
which can also be said to have been pounded and
sieved. This picture collaborates with the ana-
lytical study of the manufacturing methods.

12. BOWLS

Surprisingly the main temper in the bowls is
also calcite and not chalk. The calcite is often
recrystallized. Frequently a sieve was used, if
one takes a rather uniform size, 0.05mm., as

evidence for the use of a sieve. This is in con-
trast to sherds in which all sizes are found, from
occasionally 1cm. (rare) to mostly <0.25mm. and
much smaller. Twenty-seven sherds were examined
representing bowls, types 2, 4-6, 9-13.
Calcite <0.05mm. in high concentration (4-10
grains or more per $0.25mm^2$.) was found six times
in types 4, 6 and 10. However the fine grit is
not restricted to these types. It is possible now
to distinguish all the sherds containing this fine
grit in high concentration from the ones contain-
ing also coarser grit (see Charts 7 and 8).

Some descriptions of fine and coarse grit are
as follows.
Bowls, type 4 (see Section 36).
a. Calcite, mostly <0.04mm. Density, 10 grains
 per $0.25mm^2$. Sporadically grog and broken
 shells. The sherd has a secondary lime de-
 posit.
b. Calcite, <0.1mm., ca. 3 grains per $0.25mm^2$.
 Sporadically chalk grains and grog.
Bowls, type 10 (see Section 42).
a. Calcite and some lime grains, <0.04mm. Density
 8 grains per $0.25mm^2$. Some shell fragments and
 grog.
b. Lime, mostly <0.25mm., some calcite. Sporadi-
 cally grog, less than 1 grain per $0.25mm^2$.

This may give a fair idea of the difference be-
tween the two temper groups. Both consist of the
same type of rock: primarily calcite, sometimes
mixed with chalk. The size is likewise a criteri-
on which ought not be neglected. The fine calcite
temper (0.05 to 0.04mm.) parallels the size and
kind of temper in cooking pot, type 10, described
above.

The point is that potters became aware of the
need to control temper size and began to crush it
as finely as possible. The presence of macro-
shells (to be distinguished from microfossils) and
the sporadic presence of grog may be accidental.
Sporadically means less than 1 grain per cm^2.
One can be fairly certain that there was a trade

in calcite as it was used in vast quantities.

13. BOWLS WITHOUT TEMPER

One group of bowls has to be mentioned. This group is distinguished by the ware. The bowls have the same shape as bowls, types 1-10, but are never burnished. They are coated with a red slip inside and over the rim. Seven thin-slides were made. They all seem to have been fired at low temperatures. The clay composition is not distinguishable under the microscope from the composition of burnished bowls, and there is no trace of any temper.

One sherd from type 1, one sherd from type 2, and one sherd from type 9 contained only few grains of lime and calcite, <0.25mm., 1 grain per mm^2. or less; this is very low compared to all other sherds. Apparently the clay was occasionally used without any addition of tempering materials. This clay seems to have reacted differently to firing (Franken, 1973). See Section 31.

14. BOWLS WITH DIVERGENT TEMPER

One sherd was found, classified as bowl, type 13, containing temper foreign to the normal group. The clay is non-silty and contains grains of undissolved clay with bands of iron in it. The undissolved clay particles are also non-silty. This type of clay is often found in the Deir cAllā pottery. The temper too is in agreement with a different origin: chert and quartz in rounded grains, and lime grains, mostly <0.25mm. in a density of ca. 5-10 grains per mm^2.

15. JARS

Only two sherds were analyzed. Jar, type 1

(see Section 51) which belongs to the Iron Age I
tradition, was fired near the vitrification point.
Carbonate in the clay, if there was any, no longer
shows up. There are some very fine fine quartz and
chert grains, mostly <0.1mm. in small quantities,
ca. 1 to 2 grains per mm^2. This falls entirely out
of the normal pattern but agrees with the Early
Iron Age situation at Deir ͨAllā. Not many rims
were found of types 1-3; it is possible that they
all came from the other side of the Jordan or from
some workshop elsewhere in Palestine where sand was
used by the potters. Originally type 1 came from
Transjordan and not from the Late Bronze Palestini-
an tradition. Whether the types 2 and 3 that are
related to type 1 contain the same temper or not
has not been checked.

The other jar rim belongs to type 4. It was
made of non-silty clay which was almost vitrified
during firing, so that no traces of tempering ma-
terials could be found. Secondary lime was de-
posited in the pores of the sherd. We think that
these jars were thrown (see Section 54).

16. SAMPLING AND CONCLUSION

Sampling for thin-slide analysis was done after
the whole repertoire had been studied. Further
analysis would definitely be fruitful. More urgent
however is the need to compare the results of this
analysis with pottery from other Palestinian sites.
The chert grains found sporadically in each sherd
is evidently characteristic of the Jericho clay,
since it already occurs in the same quantities at
the site in Neolithic times.

The high content of lime in three forms, (a)
carbonate in the clay bed, (b) masses of micro-
fossils washed out of the chalks, and (c) fossil-
iferous chalk grains and calcite used as a temper,
influences the manufacturing process and firing
temperatures. The clay's plasticity is reduced
and can only be worked with the addition of more

water than is necessary for plastic clays. The
sherd is porous and dries quickly (quicker than a
plastic clay). As will be shown in section 19 the
firing temperature is low. This pottery cannot
withstand prolonged firing above 850° - 900°C.
The exceptions to this are the wheel-thrown and
quartz-tempered pots. Clearly the potters had de-
veloped their own method of firing this clay mix-
ture. They stoked it to a high temperature for a
short time to get a hard surface; the core of the
sherd was hardly ever completely fired.

17. WORKING HYPOTHESIS

No further information is given in this report
about the tempering materials with the sherd de-
scription apart from the following. The amount of
sherds with coarse and fine temper, and the ones
with fine temper only, have been noted in Charts
7 and 8, as well as the number of bowls described
in section 13. Although the microanalysis is by
no means exhaustive, more information has been
produced here than in the traditional description
of grit.
Basically the temper used by the local potters
was pounded calcite which was sometimes sieved.
We have found a group of bowls in which no temper
was used at all.
As a working hypothesis we assume that quartz
sand-tempered pottery, which is occasionally
found, was not locally made. The only other large
collection of thin-slides from Jericho pottery is
a sample of 100 sherds from Neolithic A and B.
With one exception no quartz is found. All the
other materials of the Iron Age are well repre-
sented in this group. Lack of quartz(sand) in the
neighborhood of Jericho can easily be explained.
The local rock and its eroded products consist of
carbonates (chalk, calcite) and their derivative
flint and chert.

18. COLOR DESCRIPTION

In agreement with the idea that pottery should
primarily be described as a product of the potter's
craft, is the attempt to make the color description
serve the same purpose. Thirty-seven sherds were
selected from the whole collection. They repre-
sented roughly all colors from near black to near
white. The colors of three zones of each sherd
were described with the aid of the Munsell soil
color charts, 1954 edition. The three zones are
the outside and inside surfaces, and the core.

The outside surface color of the sherd is not
always the color of the ware found just beneath the
outside surface. Three factors may have changed
the color of the ware on the outside surface: slip,
bloom, or chemical action of the soil after the
sherd was buried in debris (see Section 2). This
however presented no problem for our immediate
purpose. Before the colors were noted, the sherds
were cleaned by boiling them for some time in water
and by brushing them in order to remove loose dirt
and surface salts. No chemicals were used.

Before refiring, the sherds were dried and the
numbers were scratched on the body because ink
burns away in the kiln. The sherds were all fired
at the same time and, hence, as much as possible,
under the same circumstances.

The kiln was a small electric test kiln with
oxidizing atmosphere. There is no guaranty that
all sherds reached exactly the same temperature,
but they were stacked in such a way as to allow
the heat to penetrate the pile of sherds. The
purpose was to fire the sherds to a temperature
which they had not reached during the original
firing and to make sure that all the sherds were
exposed to the same temperature for a sufficiently
long time.

The kiln reached $900^{\circ}C.$ in ca. one and a quarter
hours, after which the temperature was kept between
900° and 950° for one hour. The kiln was then al-
lowed to cool off. Then the colors of the sherds

were measured again with the Munsell soil color
charts. The result is found in Chart 1.

19. THE SIGNIFICANCE OF COLOR

The results of the above experiment permit us
to draw the following conclusions. The dark grey
to black core disappears in prolonged firing. The
sherds all show one color with the exception of
the surfaces, which means that these surface
colors are only visible at the surface and not in
the break. Therefore the ware has one color. A
dark core indicates a short firing time, not suf-
ficient to allow the oxygen to burn out carbona-
ceous matter and to fuse with the iron contents of
the clay in the core. In this way the potters
produced ware which was sufficiently hard at the
surface and saved a lot of fuel. It is of course
not necessary to stoke to 900° to eliminate the
dark color of the core. It is a matter of pro-
longed firing under oxidizing circumstances at the
temperature at which the pottery was really fired.
This again means that pottery in the ancient kiln
near the fire has a less dark core than pottery
stacked in the top of the kiln or further from the
flame.
It would seem sufficient to note that, since
most of the Iron Age Jericho pottery has a dark
core, the potters aimed only at a hard surface of
the pottery. By way of 'imperfect' firing they
saved a considerable amount of fuel. Generally
there is no question of reduced firing.
At the temperatures reached, the lime is neu-
tralizing the iron color and the reds are lighter
than at lower temperatures. Sherds that retained
a dark red core can be supposed to contain less
carbonate in some form or other.
After refiring, most sherds had obtained this
same reddish color. The color differences on most
of this pottery can be explained by the following
facts in various combinations.

a. The amount of carbonates in the clay and the size of the grains,
b. The position in the kiln,
c. The difference in temperature in the top of the kiln and near the flame,
d. The duration of the highest temperatures reached at various levels in the kiln,
e. The direct or indirect contact with free flowing heat, that is, whether the wall of a pot was shielded from the heat flow by other pots.

Dark spots on the outside and a dark inside point to reducing circumstances or lack of oxygen and not necessarily to lower temperatures. One finds dark spots with a reddish zone around them where the wall touched another pot.

Two more aspects of color description must be mentioned. In some cases a slip layer became visible after refiring; this was due to the burning off of lime incrustration. Similarly, in one or two cases the grit showed up after refiring.

The pottery which was locally made and which exhibits all the well-known color variations could theoretically be grouped according to firing temperatures, provided clay and temper composition are taken into consideration. The results of the analysis of the factors that influence the color are sufficient to conclude that the pottery was fired at temperatures between 700° - 850°C. producing dark cores and dull brown colors. The color of the surface itself is influenced by lime incrustration, slips (see Section 4), scum, or all three factors.

20. HARDNESS

Clearly, whenever 900°C. was reached in the lower parts of the kilns, the pottery in that temperature range was wasted. Of five cooking pots only the wheel-thrown pot with the very fine quartz temper (see Chart 1:2; type 12) survived undamaged. Compare section 11.

Cooking pot, type 6 (Chart 1:14) had hair
cracks on the surface. This is a sherd with a
fine sand (quartz and chert) temper. The other
three disintegrated through expansion of the lime
(calcite) temper after refiring.

Four bowl sherds with coarse calcite temper
broke into small fragments, three others had
cracks running completely through them and a num-
ber of sherds had small cracks. This shows that
lime tempered pottery with a high amount of car-
bonates in the clay body cannot become hard pot-
tery. There is a critical temperature at which
$CaCO_3$ begins to lose its crystal water. It is
then reduced in size and closed in by the fired
clay body. After a very short time the lime takes
in the water again, expands and destroys the
sherd. This means that the sherd is bound to dis-
integrate after firing at temperatures not high
enough to bring the clay body near vitrification,
or to make it really hard. The dark cores indi-
cate a short firing time to produce hard surfaces
and a softer core. This also reduces the risk of
lime decomposition during firing. Fine lime tem-
per is less dangerous than coarse lime grit.
Really hard pottery in Palestine is quartz or
basalt tempered ware.

The cooking pot, type 2, poses a special prob-
lem. These pots with a coarse calcite temper in
very high concentrations (sometimes one part cal-
cite to two parts clay) disintegrate after re-
firing to 800°C. for half an hour. The sherd does
not flake off but becomes powder. This is in con-
trast to other pottery with calcite temper from
the same period which begins to crack when fired
above 850° - 900°C. for half an hour or more.

The dark reddish-brown color of the cooking
pots is not caused by the calcite temper; this
means that the clay was mixed with another ingre-
dient. These cooking pots could only be fired in
the top layers of the kilns or separately. Since
it is clear that the origin of these pots is not
Palestine, it is possible that they were made by

potters who specialized in cooking pots, baking
trays, etc. Such a trade would plausibly explain
both why the Iron Age II cooking pot turns up in
Palestine a long time after it is found at Deir
[c]Alla, and the fact that it existed already in the
Transjordanian Late Bronze Age. This would large-
ly eliminate the diagnostic value of these cooking
pots as time indicators.

Another important fact concerning hardness is
that in this period harder pottery turns up in the
group of fine quartz tempers; this seems to be
connected with the introduction of throwing as a
technique of potmaking.

The conclusion is that the carbonaceous Lisan
clays from Jericho tempered with carbonate rock
produces invariably soft pottery, and cannot be
fired to the maturing range. Sherds will more
often than not have dark cores due to a short fir-
ing period. Lime tempers tend to neutralize the
influence of iron on color (see Section 16).

21. COMPARATIVE POTTERY STUDY IN THEORY

The previous sections are an attempt to knit
into one coherent picture the following elements:
clay substance, tempering materials, firing tem-
peratures and colors, hardness and methods of pot-
making. A distinction has been made between the
local pottery and pottery belonging to another
tradition, and between hand-made and thrown pot-
tery. A closer definition of the pottery must be
obtained from a description of the types (see
Sections 26-58).

Some notes on pottery that can be compared with
these types have been added in those sections, but
the following restriction as to the value of this
last procedure has to be made. If one considers
the potmaking activities at Jericho as a genuine
craft - and we have every right to do so - the
previous study of the raw materials, potmaking and
firing, when taken together, describes the craft

at one stage of its development, roughly the
'tradition' of the 7th century B.C. This descrip-
tion is by no means complete, even if one takes
the rest of this report as part of the descrip-
tion. It is an attempt to picture the potters at
work and to understand what they were doing. To
complete this picture requires more pottery and
more comparison with similar studies.

It has already been pointed out that these pot-
ters stood in the tradition of the Iron Age I pot-
making methods in Palestine and had inherited the
craft. They came to the site when it was built up
again with a knowledge of potmaking inherited from
somewhere else, and adapted themselves to the lo-
cal circumstances. The Jericho Iron Age pottery
represents a section in time out of the history of
the craft. It has been suggested already that
this history of the craft is approaching its end
during the 7th century B.C. It is in the process
of being replaced by a method of throwing.

In section 7 it has been demonstrated that the
statistical evidence points to a fairly wide mar-
gin of error in the evaluation of the evidence
from each separate phase. Only when groups of
phases are combined can one say that most rim
shapes - as made by the potters at that time - are
represented in the collection. This is also wit-
nessed by the fact that certain shapes only recur
after some phases have elapsed. One cannot a pri-
ori assume that those missing shapes in certain
phases were not made by the potters. In other
words extension of the excavated area would pro-
duce these missing shapes.

As part of the craft and its historical tradi-
tion the potters had a production program, in the
sense that they worked according to a routine
which comprised the shapes they produced and the
amount. Only external circumstances would make
them change their program, for instance the arriv-
al of more colonists, or a strengthening force for
the local garrison etc., or changing demands, such
as the increase of the cultivated area and in-

crease of local processing of products. Shapes
adapted to the demands of the products would turn
up in the excavated material.

The question remains however what caused that
almost imperceptible change in shapes, resulting
from routine production, that are generally taken
as reflecting chronological differences. One pos-
sible answer is that the customers learned by ex-
perience that a certain rim profile was stronger
than another, and demanded the better constructed
rim. The weaker variant died out. Another possi-
ble answer is that increase in demand made the
potters search for quicker production methods,
resulting in a change of shapes. Yet this does
not explain why potters at different places in the
country should all simultaneously change shapes or
introduce new ones.

The attempt to synchronize phases or strata at
different sites is based on the assumption that
this was indeed the case. Or one assumes that
there were pottery markets where various potteries
traded their wares. If the latter were the case,
pottery found in one phase could come from differ-
ent potteries. From the thin-slide analysis one
can deduce that this was true for at least some
pots at Jericho.

It cannot a priori be denied that at some stage
in the 7th century B.C. most of the pottery found
in Palestine seems to be at the same level of
shape development. This is witnessed by the dif-
ficulties in dating phases that stem from this
period. This could mean that some development
took place at some sites at a given time, after
which the routine was resumed in the production of
the new shapes and techniques. Then other potter-
ies slowly took over the new fashion until even-
tually the old production was stopped in the whole
country, and nothing new was added for some time.
Nevertheless local developments in minor details
could have taken place all the time.

In the traditional comparative pottery studies
from this period the individual pots are compared.

The unity of the total production is fractioned
and the coherence of the picture lost. But what-
ever the explanation of a synchronized development
of the potter's craft in a country or a region
- if at all synchronized - one has to sort out
what was not locally produced, rather than what
was produced based on a comparison of the total
production of the different sites. One assumes
that the same types were produced simultaneously
in various places, so what is left is to trace
these production centers by their own peculiari-
ties, or by methods and shapes that were not pro-
duced by others. Furthermore, in order to see
whether synchronization was already complete or
not, one has to assume that it is possible for
earlier shapes to occur occasionally somewhere in
a later context, whereas contemporaneously a devel-
opment had already taken place elsewhere.

In other words, studying pottery for its value
as time indicator is literally the last thing one
can do before these questions are answered. If
the sketch of the craft, as given above, is taken
as a skeleton model of the pottery under discus-
sion, this model as a working hypothesis will have
to be compared with models made from pottery stem-
ming from the same general tradition found at
other sites. The model is a description of the
craft as found in one pottery in a certain stage
of its development. Since the centers of produc-
tion as a rule are unknown, it is all the more
necessary to compare all the data that can be made
available. As is often the case in the use of
statistical data, one can predict what the chances
are that two sites with 'identical' pottery groups
date from exactly the same time, but one cannot
demonstrate in the particular case that there is
not a difference of a generation of potters in
time.

Statistical data have to be used to demonstrate
the reliability of the sample (see Section 7). In
addition, the ratio between types for each indivi-
dual phase has to be worked out for comparative

studies. For tracing production centers the lat-
ter is indispensible. The value of this statisti-
cal method for working out the relative duration
of each phase must be tested since it could prove
to be an extremely valuable method when combined
with C14 dating, for accurately dating the dura-
tion of each of a series of phases (Franken &
Kalsbeek, 1969 (2)).

22. WORKING HYPOTHESIS FOR TYPOLOGY

The working hypothesis used in this report can
be described as follows. When the site was re-
built in the Iron Age, potters came to work in
Jericho who stood in the Iron Age I tradition of
potmaking in a stage of its development in the
period Iron Age II.
The presence of so-called earlier pottery can
be explained in three ways.
a. It may indeed date from an earlier period,
b. It was still being made by the potters or local
 inhabitants of the oasis of Jericho,
c. It was brought by nomadic tribes that occasion-
 ally visited the site, some of which may have
 crossed the Jordan River.
The local potters kept up with the development
in the mountains, but not necessarily at the same
pace. Influences from Transjordan can be expected
at this border site. The break-through to the
thrown pottery has left some traces in this group
of pottery. Thrown wares may have found their way
to the site by trade. Comparative pottery studies
must be based on comprehensive working models of
the local craft and not on individual pieces.

23. PUBLICATION OF THE TYPOLOGY

The method of the foregoing study has three
elements which have to be considered when publish-
ing pottery in drawings.

a. The typology has to be based on the techno-
logical study of the material. Here the
material consists of bases, handles and rim
sherds. Since complete shapes have not been
found, the technology of the bases, handles and
rims has been separately treated. The rims
have been divided into cooking pot rims, bowl
rims and jar rims. Each of these groups is
subdivided into types according to the differ-
ences in treatment. This results in the fol-
lowing types; subdivisions of types are not
included.
Bases, 6 types (see Section 24); Handles, 3
types (see Section 25); Cooking pots, 12 types
(see Sections 26-29); Bowls, 17 types (see
Sections 30-49); Jars, 9 types (see Sections
50-58); Miscellaneous.
b. Sherds are defined as types and not as indi-
vidual sherds. As far as possible the clay,
tempering materials, firing temperatures, color
and hardness have already been related to each
other. Naturally, if each of these five as-
pects were measured on a scale of 10 points,
individual sherds could differ as much as 10^5
points. This prohibits exact descriptions of
each sherd, and obviously it is unnecessary as
long as the limits of the possibilities for
each of the categories are broadly outlined.
Quite apart from this general aspect the scope
of the continuum is further narrowed by the
fact that two elements are combined in this
kind of description: the manipulations of the
materials by the potters, and the chemical and
physical reactions caused by the manufacturing
processes. The first element limits the second
drastically and vice versa. This is all the
more reason to study these features from the
sherds, and then summarize according to the
purely technical aspects of potmaking (or the
types) found by the analysis. A different
treatment can result in a different appearance.
See for instance the differences in cooking

pots.

c. Tendencies in development of the craft can only
 be studied from stratigraphic sequences, if one
 has a sufficient amount of sherds per phase.

The system of typology is built on these prin-
ciples. First, the types are described and further
technological information added for each type. A
survey is then made of the types found per phase.

It is possible to condense such a survey much
more than has been done in this report. Under
ideal circumstances it suffices to publish the
types, some variants and the shape evolution if
present. The evidence from the stratigraphy can
be published in charts similar to the ones publish-
ed in this study. Since types are described in
terms of raw materials, chemical and physical pro-
cesses and manufacturing methods, this material
lends itself to automatic processing as part of
larger programs of comparative pottery studies.
When thinking in terms of computer programs the
whole content of this report can be condensed into
tables. But at present it is necessary to present
the reader with the evidence in some detail to
show what exactly the meaning is of this new ap-
proach in relation to the conventional method of
publishing pottery typologies.

24. TYPOLOGY OF THE BASES; Fig.1

The typology of bases is literally basis for
the understanding of pottery as soon as the methods
of construction are taken into consideration.

Until now base fragments have been attributed
to pot shapes in the existing literature. They
play a minor role in typological studies which
concentrate on rim shapes. The following typology
of bases is limited to the existing material in
the Jericho repertoire, but the evidence from Iron
Age I has been taken into consideration. Six con-
structional types can be distinguished.

Types 1 and 2
 The complete pot shape is made from the cone
(lamps, small bowls, juglets).
Type 3
 The vessel is built up in coils on a cake of
clay which is reshaped afterwards to shape the
base. Inside and outside: bowls; on the outside
only: jars.
Type 4
 The vessel is built up in coils and the last
coil added is made into a base by turning the
shape upside down on a slow wheel and by making a
dome shape (cooking pots, jars).
Type 5
 The vessel is turned from the cone and removed
by pinching the lower part; after being pinched
off the base is modelled (dippers).
Type 6
 The vessel is built up in coils, cut away from
the turning base (if one was used in this case)
and slabs of clay are used to form the base (large
heavy bowls and jars).
 This typological system is represented in Fig.
1. Drawings showing the different construction
methods step by step have been published in
Franken, 1974.
Type 1
 Fig.1:1-4 (lamps) and 5-8 (small bowls) depict
bases of types 1 and 2. The two groups look quite
different but technically there is very little
difference.
No.1 is the lamp with a heavy foot. These lamps
are small bowls with wide rims. Part of the cone
from which they were turned is still attached to
them. Occasionally this lamp without the wide rim
is found as early as the 12th century B.C. There
is a good stratified example from Deir ᶜAllā. This
is not surprising since the basic technique is the
same. Only in the 7th century B.C. were lamps
found to which part of the cone was left purposely
attached to the base. (In earlier times the pot-
ters used to cut the lamp from the cone, put it

aside until the rim was dry, and then scrape the
base, holding the lamp in one hand. It could not
be put back upside down on the wheel. The re-
worked bases are neither round nor centered.)
No.4 (unstratified) shows the next development.
The sherd has fine grit. The lamp was properly
thrown from a plastic clay. One has to assume
that the wide rim became impossible: because the
walls would have collapsed. The early thrown
lamps are very irregular near the base until they
become smaller. The wide rims disappear and in-
stead of the pinched spout the two sides of the
turned up rim (where the spout is to be made) over-
lap. From the technological point of view this
development is perfectly understandable. The tend-
ency toward working with a finer temper, which re-
sulted in better plastic properties of the clay,
may have influenced the shape of the rim before
throwing became general practice. In order to
counteract deformation of the lamp caused by the
pressure of the weight of a wide rim made from a
more plastic clay, the potter tended to push the
sides of the spout closer together. The result
was a very low rim near the spout which drastical-
ly reduced the oil capacity. This may be an in-
stance of a change in shape resulting from a tech-
nical change. The wide rim disappears because it
causes deformation and a simpler, more effective
shape appears.
Type 2
 Fig.1:5,6 and 8 belong to a group of small bowls
which could have been made from the cone in the
same way as the lamps. The insides of these bases
have been smoothed while the clay was still wet;
on the outside one invariably finds traces of
scraping away surplus clay, which was done after
the base had dried somewhat (as soon as the rim
became leather-hard, and the bowl could be held
upside down). There are no traces of quick turn-
ing. The bases are not circular. The wall near
the base was also thinned with a rib, resulting
sometimes in a slightly profiled base shape (no.8).

No.7 is a heavier bowl, and the base was made in
exactly the same way: reshaped after the rim was
finished.
Type 3
 Fig.1:9-13 belong to larger bowls and jars,
made by coiling. The base was heavy to begin with,
it was then thinned after the rim was finished and
leather-hard. In the process of thinning the base
clay was scraped out to form a foot-ring, which
was again made wet and remodelled. Usually the
wall of the bowl has a different thickness inside
and outside the ring. In a few cases the foot-
ring has been added separately after the thinning
of the wall. Sometimes the clay for the ring was
simply pushed from the center of the base to the
outside and wet-smoothed (no's 12 and 13).
Type 4
 Fig.1:14-16 are bases made from the last coil
used to make the vessel; presumably they are jars.
The jar was made by coiling; the lower part was
made after the upper part was finished and dried.
This method is an invention of the 12th century
B.C. The process is described in Franken, 1969,
pp.103 and 161. The result is a round base (no.
14), which can be pushed to the inside, thus
making possible the pinching out of a ring (no.15)
or the flattening (more or less) of the base
(no.16).
Type 5
 Fig.1:17-19 clearly show the turning marks in-
side. The outside has been wet-smoothed. These
dippers were made from the cone, and either cut
away above or below. Whether cut away above or
below the base, the base was finished in a turning
movement, surplus clay was scraped away and the
outside wet-smoothed.
Type 6
 Fig.1:20 and 21 are bases of very heavy pots,
bowls or jars, with a foot-ring added or made from
surplus clay. It is impossible to say whether the
pots were built up from a very heavy base which
was reshaped afterwards, or whether the base was

the last part to be made by adding slabs of clay.
The fact remains that to control the thickness of
the base was difficult. Occasionally these bases
were separately made and added, or they were
strengthened by the addition of clay cakes. This
method of making bases is found for a short time
in the 12th century B.C. at Deir ᶜAllā (Franken &
Kalsbeek, 1969 (3)).

In the next period, when throwing becomes com-
mon practice, bases are reshaped on the wheel or
closed on the wheel during throwing. The five
methods of making bases described above all come
from a tradition of making pottery by hand with
the aid of a slow wheel.

25. TYPOLOGY OF HANDLES; Fig.2

There are two different types of handles and a
transitional stage - technically speaking - between
the two. The first type dates from Iron Age I.
It was made as follows. A clay cake was flattened
into a square sheet. Then two parallel folds were
made lengthwise and these were further made into a
roll. In broken handles of this type, the folds
can often be seen. These handles can be recognized
by the uniform diameter over the whole length. The
handles were finished in three ways, which are usu-
ally not clearly distinguishable. In section they
are round, triangular, or flattened (Fig.2:1-7).
Both ends of these handles are attached perpen-
dicularly to the pot. The area of contact with the
vessel is the same for both extremities. This is
possible with less plastic clays. It is not possi-
ble with the second type of handle found in this
pottery. These are pulled handles, made of a
plastic clay. The technique is typical for a tra-
dition of thrown pottery, although it is occasion-
ally found on hand-made pottery as well. The
amount of clay needed for the handle is shaped like
a cone; the base of the cone is attached to the
pot. Then the cone is pulled between thumb and

index finger to make it longer, and sometimes be-
tween two fingers to make it flatter. The result
is a handle tapering toward one end. The area of
contact of this end with the pot is too small when
perpendicularly attached. It is therefore attach-
ed obliquely and often strengthened with a sepa-
rately made clay cake on the inside. The thin end
of pulled handles tends to break away from the pot
without a body sherd attached to it, whereas the
handles of the first type often break with a body
sherd. Hand-made cooking pots all have rolled
handles; wheel-thrown pots have pulled handles.
 Fig.2:8-12 represents the pulled handles, which
partially belong to the 'transitional' group.
These handles were folded and rolled, but they
were also finished by pulling. This is apparently
an experimental stage. In addition to the tapering
shape and the way of attaching, there is a slight
ridge running lengthwise over the handle.
 The first really pulled handle is found in
phase 14.
 Type 3 (Fig.2:13-15) is rare. Probably no.13
and certainly the other two are intrusive Medieval
Arabic handles made from a white-firing clay. They
may have a different technical background.

26. TYPOLOGY OF HAND-MADE COOKING POTS
 Fig.3 and Chart 2

 Type 1 is the common cooking pot found in Iron
Age Jericho. In Palestine it replaces the Iron
Age I type which is found there from the 12th to
the 8th century B.C. (see Jericho, type 2).
It is clear from the stratigraphic evidence from
tell Deir ᶜAllā that both types had been developed
already in the 13th - 12th century B.C. in Trans-
jordan and existed independently of each other.
They may indicate different tribal traditions.
Both types were introduced into Palestine, and are
not descended from the Late Bronze Age Canaanite
cooking pot. Both contain calcite temper and both

were originally made in a large, rather shallow
mould.
Type 1
 Type 1 develops from a wide-mouthed pot, which
did not as a rule have handles. In the course of
time the mouth became narrower, as the original
tendency to carination is lost in the process of
quicker turning. Thus, the shape changed from a
wide, low pot to a narrower, higher pot with two
handles. The rim was made with one fold to the
inside, whereas the Iron Age I cooking pot
(Jericho, type 2) was made with two folds. If a
cooking pot did not break accidentally, the base
burned after some time and disintegrated. This
explains why few bases of cooking pots are found
during excavation.
 It is highly probable that at this time the up-
per part of the pot was first constructed by coil-
ing, and that then the lower part was made while
the pot was standing upside down on a slow wheel.
Turning marks are found on the wall inside but not
on base fragments. The base was smoothed inside.
The wall outside often shows the marks of dry-
scraping. The clay was made lean by adding large
amounts of calcite temper.
 The basic shape of the rim has three character-
istics (see Fig.3:1).
a. The fold to the inside, which was necessary to
 make the top of the rim horizontal and to dis-
 pose of the surplus clay of the last coil, ex-
 plains the hollow just below the rim. The pot-
 ter supports the neck with a finger on the in-
 side when making the fold.
b. This horizontal hollow corresponds to a ridge
 on the outside.
c. The rim is twice the thickness of the wall.
 Each of these features may show the influence
of further treatment.
 Both the hollow on the inside and the ridge on
the outside still exist in this period, but several
developments take place. The hollow can disappear
because it is filled up, but further treatment of

the folded rim may cause a new hollow on the in-
side. The ridge tends to be pushed up giving the
pot a short vertical neck. The hollow and the
ridge no longer correspond to each other as is al-
ways the case in earlier periods.

The folded rims are reshaped by further treat-
ment. There are clearly two groups.
Type 1a

Rims which are thin due to the pushing up of
the clay.
Type 1b

Thick rims which could be reshaped in different
ways.

There is enough of the thin rims (type 1a) to
ascertain their stratigraphical position. That
they have handles and that the mouth is often
smaller than that of the earlier type confirm that
they belong to the same period as the cooking pots
with the thickened rims. The following table
gives the relation between types 1a and 1b.

Phases	Type 1a	Type 1b
24-17	23	14
16-10	89	11
9-5	16	1

Fig.3 shows a number of variations. Depending
on which rim treatment is stressed one can con-
struct various groupings. Fig.3:1 is no longer
found in this period. It represents the shape in
Iron Age I, as the 'undeveloped' shape described
above.
Fig.3:2-5 are the rims with the original hollow
inside covered up by the fold. The rims are as
thick as the wall or slightly thicker. No's 3-5
tend toward pushed-up outside ridges. No's 2 and
3 have rims not pushed upright; no's 4 and 5 have
rims in a more vertical position.
Fig.3:6 and 7 have preserved the hollow inside.
The thickness equals that of the wall. No.6 is
close to the Iron Age I shape. No.7 tends to a
pushed-up outside ridge.

Fig.3:8-11 are thickened rims. In this group one
sees the tendency to make the ridge and the top of
the rim meet. The result (no.11) is a narrow
groove on the outside in the thick rim. They have
preserved the hollow inside. The top of the rim
is pushed down and flattened in the direction of
the neck.
Fig.3:12-14 are thickened rims which are flattened
on top. This results often in a rim bent inward
horizontally.
Fig.3:15 and 16 are thickened rims which tend to-
ward a pushed-up outside ridge with the top of the
rim bent inwards.
Fig.3:17 and 18: the pointed end of the rim is
pushed up.
 Rims forming a straight contour with the neck
of the pot are still clearly found. This contour
changes when the ridge on the outside is pushed up
although this does not mean that the rim is verti-
cal. When this is done, the hollow inside is some-
times carefully preserved, although it would seem
that the hollow would disappear with this treat-
ment. Both the thin and the thickened rims may
appear in a vertical position. The distinction
between thin and thick rims may be purely acciden-
tal, depending on the amount of clay in the top-
most coil. The original relation of the hollow to
the ridge is lost. That both were preserved seems
typical of the traditional character of the potter
's craft, in so far as they were now more or less
artificially made. The necks of large jars pre-
serve this ridge plus hollow, even after the origi-
nal shape of the neck had changed (see Jar, types
1-3).
 When the outside ridge is pressed up vertically,
the neck of the pot is short and straight.
Compare Fig.3:7,8-11,12-14, 16,17. This feature
may have been of some importance in the development
of a cooking pot with a high vertical neck.
Compare type 4).
 Analysis of the potter's method of shaping the
cooking pot rims demonstrates that comparing one

shape with pots from other sites is of limited
value. There is a range of possible rim shapes
permitted by a few basic treatments and the amount
of surplus clay in the last coil. And decisive
for this range of variation was the traditionally
known treatment. Groups should therefore be com-
pared rather than individual pieces.

Another aspect of this type of study is that it
makes clear that change in treatment or a set of
treatments or tendencies in shape development can
only be studied from a larger amount of stratified
material than is available at present. As it
stands, every phase may produce the same range of
shapes because there is no noticeable change in
the manufacturing methods. From the thin-slides
(see Section 11) it would appear that the pots
were manufactured near the site.

The other types of cooking pots are rare.
Nearly all have been drawn and added to the sur-
veys of pottery found in each phase where they can
be easily found (see Chart 2).

Type 2

There are only four sherds of this type. The
rim shape resembles that of the Iron Age I cooking
pot with two folds: first to the inside and then
to the outside. The pot was made in a mould, had
a wide mouth and no handles. In Deir CAllā a
tendency has been noticed to assimilate the shape
of this pot to that of its successors. The
Jericho, Lachish and stray specimens are late
survivors of the 12th century tradition. It is
possible that itinerant groups of potters in
Palestine and Transjordan kept this tradition
alive. One cannot deny that it still existed in
these later periods.

See Fig.7:3; Fig.9:2, phase 19; Fig.12:5; Fig.
14:6.
(Compare Tufnell 1953, Pl.104, no's 684, 685 and
693 from Tomb 120 (ca. 900); Aharoni 1962, Fig.
27:2, Str.V, Late 7th century.)

Type 3

Several L.B. cooking pots were found. There

are three specimens with the same shape belonging
to the Iron Age. Fig.4:7 has an Iron Age handle.
 Type 3 may be a development of type 1 (the out-
side ridge being pushed up to the top of the rim).
The tendency for the ridge to be pushed up is seen
on type 1. Type 3 often shows a tiny groove run-
ning over the top of the rim, which is not caused
by an incision but which indicates the rudimentary
outside ridge. The top of the rim is turned to
the outside. Although type 3 resembles type 12,
the latter shows a new development. Type 3 belongs
definitely to the hand-made cooking pot tradition,
whereas type 12 is wheel-made. Type 3 has handles
in the Iron Age, but not in the Late Bronze Age
tradition. In the Iron Age it lacks the carination
and has a smaller mouth.
See Fig.9:3, phase 21; Fig.9:3, phase 19; Fig.12:6;
Fig.14:7; Fig.17:5, phase 8.
(Compare Yadin 1958, Pl.55:5, Str.V. Both specimens
are the same size as the ones from Jericho; Ibid.
Pl.70:8, Str.IV.)
Type 4
 Only seven stratified specimens were found.
Type 4 may represent a further development of type
1 with the rim pulled up. Profiling tends to dis-
appear and the rim is pushed out.
See Fig.8:4; Fig.9:4, phase 21; Fig.11:4; Fig.12:7.
(Compare Crowfoot 1957, p.189. Cooking pot class
E and F. Ibid. Fig.12:11,12, a deep cooking pot
with a similar rim, from the late 7th century;
Lapp 1968, p.67 and Fig.19:10,11 ('Late Iron Date'
640-587 B.C); Yadin 1958, Pl.76:10, Str.III.)

27. TRANSJORDANIAN INFLUENCES
 Cooking pots, types 5 and 6

 In the hand-made group a number of sherds were
found which strongly resembles pottery found in the
region of Madaba, especially at tell Jalul.
Type 5
 Type 5 consists of sherds that do not show the

outside ridge of type 1. The rim is usually
thickened, like a band, and is either flat or has
two or more grooves, or a thickened second band.
The last one, found in phases 10 and 7, resembles
a type found at Deir ^cAllā (Franken & Kalsbeek,
1969 (4)).

Only nineteen stratified sherds were found with
regular and seemingly proportionate distribution
through all phases. Occasionally these types were
found in Palestine. The comparatively frequent
occurrence in Jericho is important for the dating
of Transjordanian pottery.
(Kenyon 1965, p.511, Fig.259:3 seems to belong to
this type and not to type 10. However the paral-
lels quoted here refer to type 10.
Crowfoot 1957, p.187, Fig.30:1 may be Jericho,
type 5, but there is no evidence that this pot be-
longs traditionally to Samaria group A cooking
pots. Compare Yadin 1958, Pl.73:4, Str.V; 1960,
Pl.94:18, Str.V.)

These pots are mostly wide-mouthed, like the
types 1 and 2 in Iron Age I in Palestine. The
wide-mouthed cooking pot reflects different food
habits than those reflected by the cooking pot
with a narrow mouth. The pot with a flat band
around the rim (phases 10 and 7) is characteristic
for tell Jalul.
For the distribution over the phases, see Chart 2.
See also Fig.8:5; Fig.9:5, phase 21; Fig.9:4,5,
phase 19; Fig.11:5-7; Fig.12:8,9; Fig.13:2; Fig.
14:8-10; Fig.16:6; Fig.17:2,3, phase 8; Fig.17:6,
phase 7; Fig.19:2.
(Compare Yadin 1960, p.27 and Pl.69:21, Str.VI;
Pl.85:15, Str.Va; and Pl.99:21, Str.IV.)
Type 6
Type 6 is a clear example of Transjordanian
influence. Two sherds were found, Fig.9:6, phase
19 and Fig.17:7, phase 7. Many similar rims occur
near Madaba, but they are usually much wider.

As a matter of fact all the types listed above
have their origin in Transjordan or migrated

through Transjordan into Palestine. To the extent
that types 1 and 2 continued to be developed in
Transjordan, this development was independent from
that in Palestine (compare Section 51).

The excavation at tell Deir ^cAllā has made it
clear from the stratigraphic evidence that in the
13th century B.C. at least three different tradi-
tions of cooking pot making existed in Transjordan
side by side, while in Palestine the Late Bronze
cooking pot was still being made. This shows that
the history of the Iron Age Palestinian cooking
pot is more complicated than has been assumed.

Thus Jericho, type 1 had replaced Jericho, type
2 in Deir ^cAllā a long time before type 1 was
introduced into Palestine. Since the two types go
back to different origins and traditions, the
question remains why the Palestinian potters aban-
doned the manufacture of type 2 in favour of type
1. The solution may be that they abandoned the
use of the mould for making the bases when they
discovered that the round cooking pot bases could
be made by turning. The finished upper part of
the pot is put upside down on the wheel and then
the base is made from coils added to the finished
part. Another reason may be that more and more
cooking pots were wanted which were narrower and
deeper than the Iron Age I pot. The very wide
pots seem to have been nomadic pots in origin. It
is not at all surprising that Transjordanian pot-
tery occasionally migrated to Jericho in the 7th
century B.C.

28. THROWN COOKING POTS

Types 9-12 and probably types 7 and 8 belong to
a new method of potmaking. They are properly
wheel-thrown pots. Their main technical character-
istic is a very fine temper used in the clay. This
pottery gives the impression of being darker than
the other types due to the fact that the temper
was added in the form of fine powder.

For the first time since the Middle Bronze Age
in Palestine no grit is found in this pottery
which has not been sieved. The clay was prepared
with the greatest care. Potters of the 7th centu-
ry B.C. had found a solution to the special prob-
lem of preparing cooking pot clay for throwing,
something the Middle Bronze Age potters never suc-
ceeded in doing. Their cooking pots were hand-
made.

It should be noted that it is absolutely impos-
sible to throw the shape of the wide carinated
Iron Age I cooking pot on a wheel. But from this
period thrown cooking pots are found in Palestine
with round bases made upside down on the wheel.
This technique occurs well into the Arabic period,
when the Byzantine type cooking pot was slowly re-
placed by the hand-made cooking pot which was made
in coils.

Although the potters of Palestine made a great
deal of progress toward the re-discovery of throw-
ing, it is clear that in the 7th century B.C. both
techniques existed side by side, so that the final
step toward throwing was probably made in one or
more centers of potmaking under influence from
abroad. As will be shown from the evidence of
type 9, the thrown pottery in the Jericho reper-
toire was probably not made in Jericho but bought
from a pottery market where thrown pottery had
been introduced. Full scale throwing is not found
in Palestine before the 6th century B.C. It is
clearly connected with the Assyrian or Babylonian
impact on the Palestinian civilization.
Type 7

Only one stratified sherd was found in phase 5
(Fig.19:3) and one unstratified. Their classifi-
cation as wheel-thrown is uncertain. The temper
is very fine.
(Compare Yadin 1958, Pl.74:20, Str.V.)
Type 8

Only one sherd was found in phase 22 (Fig.8:6).
The temper is coarse. This may have been an at-
tempt at throwing.

Type 9

The profile of the rim is made with the aid of
a template on the plastic clay. This is an en-
tirely new feature. The 'x' sign often found on
handles of this type could be the 'trade-mark' of
the new factory.
(Compare Lapp 1968, p.67 and Fig.19:7-9. The Beth
Zur level is dated 640-587 B.C.
It is significant that at Tel Goren only the types
9 and 12 cooking pots have been found.
Mazar 1966, p.28 and Fig.17:3.)

The new settlers of the oasis of Tel Goren used
only wheel-made pots at a time when Jericho, type
1 was the dominant type at Jericho. Since culti-
vation on a large scale of the Jericho - Qumran
region dates from the 7th century B.C. according
to the surface finds, it is likely that these
areas were brought under cultivation during the
Assyrian domination by the introduction of irriga-
tion. This could also explain why out of the way
settlers like those from Tel Goren started off
with wheel-thrown pottery. In the literature this
type of rim is called "rilled rim". There is only
one stratified rim from phase 10 compared to six
from phases 4-1. This sherd is used for a thin-
slide. In the drawing it is replaced by a similar,
unstratified sherd (Fig.16:7).
(Compare Aharoni 1962, Fig.11:22, Str.V, second
half of the 7th century B.C.; Tufnell 1953, Pl.93:
451,452 and 456 from Tomb 1002, dated ca. 810-710
B.C. But see the corrections of this date.)

Type 10

The pot has a high, straight and narrow neck.
The temper is very fine. Two early sherds come
from phases 22 and 21, four from phases 11-8, and
four are unstratified.
See Fig.8:7; Fig.9:6; Fig.14:11,12; Fig.16:8;
Fig.17:4, phase 8.

Type 11

The neck is short and the rim is bent outward.
The top of the rim is triangular. Stratified
sherds come from phases 14 (one) and 11 (three).

There are eight unstratified sherds from phases
3-1. See Fig.11:8; Fig.14:13-15.
(Compare Yadin 1958, Pl.80:25, Str.II.)
Type 12
 The shape resembles that of type 11, but the
rim was finished differently. We find here the ru-
dimentary pushed-up ridge of type 1 in the groove
on the top of the rim. This groove was not made
with a pointed tool but indicates two flows of
clay. This is an example of new techniques and
materials being used in the beginning to make the
earlier shapes. Six stratified sherds come from
phases 15-8; eight unstratified sherds from phases
4-1. See Fig.11:9; Fig.14:16,17; Fig.17:5, phase
8; Fig.17:8, phase 7.
(Compare Lapp 1968, Fig.19:3 and p.67. Here type
12 is taken as a variation of Jericho, type 1;
Aharoni 1962, Fig.11:23,24 and Fig.28:35-37.
Quartz is mentioned as grit. Second half of the
7th century B.C.; Mazar 1966, p.28 and Fig.18,
where it is suggested that the pot belongs to the
second half of the 7th century, and not earlier.)

29. ADDITIONAL REMARKS

 The division of the cooking pots into twelve
types has been argued on the basis of different
manufacturing methods, tempering materials and
origin. When this report was nearly finished,
another significant fact came to light. Cooking
pots, types 1 and 2 could only have been fired to-
gether with other pottery types if they were
stacked in the top of the kiln, that is in the
lower temperature range below 850°C. When fired
over 850°, the coarse calcite temper destroys the
pot. It is likely that these cooking pots were
fired separately. Very little can be said about
the wheel-thrown cooking pots and their relation
to the other thrown types of bowls and jars. But
it seems no longer justified to postulate that the
hand-made cooking pots were always made by the

same potters who made the rest of the repertoire.
These pots may have been made by families of cook-
ing pot makers, and distributed through the coun-
try by means of donkey caravans. If this is so,
the history of the cooking pot of the Iron Age in
Palestine has to be studied independently.

30. POTMAKING TECHNIQUES OF THE BOWLS

As we have seen in sections 12 and 13 the tem-
pering materials of the bowls consist mainly of
fossiliferous lime, calcite and chert; not of
quartz (sand). The potters turned these bowls with
a very thick base. Larger bowls were made by ad-
ding one or more coils to the base. All the pro-
filed rims were made by turning down the upper
part of the last coil, either once (to the inside)
or twice (first to the inside and then to the out-
side). After the upper part of the wall had
dried, the bowl was placed again on the wheel up-
side down and the base was made thinner; from the
outside at the same time a foot-ring could be
left. Many bowls with a ring at the base show
considerable difference in wall thickness inside
and outside the ring. Often one finds, especially
on lamps and small bowls, that no wheel was used
for the final treatment: the base is neither cen-
tered nor circular. See Figs.21 and 22.
Some of these Iron Age I methods could be prop-
erly checked on the Jericho pottery; others could
not because the amount of bases and wall fragments
is not sufficient. There is no doubt that bases
were turned as very thick lense-shaped cakes. It
is significant that only small, thin-walled bowls
have no profiled rims, but larger, thick-walled
bowls all have reworked rims, even if they appear
straight.
It is fairly certain that the potters still
added coils when making larger bowls. Often one
finds horizontal breaks which are rare with prop-
erly thrown pottery. Throwing on a good wheel

creates stress in the clay which takes the shape
of spirals. The breaking pattern consequently
follows and cuts the spirals diagonally. The frag-
ment is somewhat diamond-shaped. Coiling however
creates much less stress, and the break-lines are
more horizontal and vertical to the coils.

Most of the bowls were treated again after the
shape was finished by scraping, wet-smoothing,
burnishing. As a result coiling does not show on
the surface of the pot. It is certain that bases
were still thinned down by scraping, mostly on the
outside but also on the inside. In the case of
burnished bowls one sometimes sees clear marks of
scraping in any directions between the burnishing
marks on the inside near the base. On the outside
one finds invariably a point below the rim where
wet-smoothing (upper part) and scraping with a rib
(lower part) meet. At this point there may be an
angle, caused by the rib and the position in which
the edge of the rib was held to the bowl (see Fig.
4, center). One also finds this evidence of
scraping on bowls which do not have the angle in
the wall. Therefore the outside angle in the wall
need not be a typological feature. In many cases
it is accidental.

When the bases are really circular they have
been scraped upside down on the wheel. Foot-rings
are either added, or made of clay not scraped
away. Then they were usually remodelled. It has
already been noted that the upper part of the bowl
was rather dry when the base was treated. The
difference in dryness can be ascertained when com-
plete shapes of burnished bowls are available.
There are two indications.
a. Burnishing is most effective on a dry clay
 body. The sheen, effected by the burnishing
 tool, will not stay if the clay surface is not
 dry or leather-hard. One finds bowls on which
 burnishing was successful (as far as the sheen
 is concerned) on the upper part, but not on the
 lower part.
b. At the same time the burnishing tool left the

upper part smooth but scratched the lower. This
means that the base was not yet dry when bur-
nished (see Section 5,c).

Yet another indication that the Iron Age I tra-
dition was still alive is that folded rims were a
necessity. They were not made level and equally
thick around by cutting the surplus clay away with
a needle, as is done in the process of throwing.
The cutting needle was not used, and it is very
likely that it could not be used, because it would
tear the clay and not make a clean cut. Under
magnification it is obvious that the non-plastic
materials are either too large (usually <1mm.) or
when smaller (<0.25mm.), they are so densely pack-
ed in the sherd that use of a cutting needle is
not possible. In addition to the evidence of
grain size, one often finds the traces of folds in
the break of a sherd. Sometimes this will show up
very clearly in thin-slides.

Unfortunately no Iron Age I sherds from Jericho
are available for comparison of the tempering ma-
terials (especially for size and quantity) with
this group, in order to see what improvements were
made in turning.

The following are the basic elements of these
bowls.
a. Making a thick base in a turning movement,
b. Shaping a rim from the clay at the circumfer-
 ence, or adding one or more coils,
c. Shaping the rim at the last coil by folding and
 reshaping,
d. Allowing the upper part of the pot to become
 leather-hard,
e. Putting the bowl back on the turning base
 upside down, and finishing the base.

When the bowl shape was finished and dried, a
slip was often painted on the outside and inside
(see Section 5). It seems that the slip was not
applied by dipping the pot. Two types of slip
were used: a red-firing and a white or creamy-
firing slip. Sometimes a bowl was coated with a
red slip on the inside and over the rim; these

parts were then burnished. But the crea-colored
slip is only found below the rim on the outside.

Handles were added before the slip was applied.
Irregular burnishing is still found occasionally.
Ring- or spiral burnishing was common practice,
and was often laboriously done in a very slow
turning movement, in which the potter needed both
hands, one to hold the burnishing tool and one to
support the bowl, while somebody else kept the
base turning.

This survey shows that making these bowls took
a long time. Firing was not a long process. Many
dark cores are found, which indicates that the
kilns were fired to the maximum temperatures which
the clay composition could endure. Then the kiln
was allowed to cool off.

31. A GROUP OF BOWLS WITH A DIFFERENT ORIGIN

Section 13 describes the thin-slides of a group
of sherds which can be distinguished from the main
group by three features.
a. The clay that was used was not red-firing,
b. No burnishing has been observed,
c. No temper was used.

There are many sherds in the collection that
are no longer reddish. This can possibly be ex-
plained by the fact that the high carbonate con-
tent of the clay neutralizes the iron color at
higher temperatures. It is a fact that this red-
firing clay becomes whiter the nearer it is fired
to the vitrification point. But the sherds from
this group never fire red. The existence of a
white-firing clay is evidenced by the occurrence
of a white slip. Sometimes a red-firing slip which
often dripped was applied to a bowl of white-
firing clay on the inside, over the rim, and occa-
sionally on the entire exterior, including the
base. The slip was always painted with a brush.

There are two possibilities of explaining this
clay. Either the clay was specially treated to

eliminate the red color, or somewhere clay was
found that fired white. It is more likely that
two types of clay were used. The clay has exactly
the same appearance as described in section 8, in-
cluding the rare chert grains with sharp edges,
and the microfossils. The maximum firing tempera-
ture is between 850° and 900°C. There is very
little change in color between ca. 700° and 900°.
The color is described in Chart 1:3, where the
outside color refers to the red slip.

The bowl shapes found at Jericho are limited to
the types referred to in the Distribution Chart 10.
This pottery is found at other sites, probably al-
so in small quantities. Some sherds were found in
the Sechem collection in the Rijksmuseum van Oud-
heden in Leiden. Few sherds occur at tell Deir
ᶜAllā.

It is important to locate these bowls because
the difference in clay and treatment could point
to an isolated workshop from which they were dis-
tributed over the country. These bowls have lost
some of their originally bright colors in the
soil. The red slip flakes off (Franken, 1973).

32. RECONSTRUCTION OF BOWL TYPES

The cooking pots have been treated on the as-
sumption that they were probably not made by the
potters who made the bowls and jars, or that type
1 was only made by them.

A similar assumption is discussed in section 31
for a group of bowls. In these cases one can at
least say that even if these pots were all locally
made, there is a foreign element which is derived
from a different tradition from that found in the
other groups of pottery. In these groups (bowls
and jars) 'suspect' sherds are found occasionally.
For instance the mortar, Fig.4:26, may have come
to Jericho by trade. This is further discussed in
section 40.

The typology of the bowls as given below serves

the purpose of reconstructing types according to
the routine work of the potters. This means that
one set of manipulations resulted in a type.
Another set of manipulations resulted in another
type. Variants within one type have only coinci-
dental value. Sometimes it is difficult to see
what is accidental and what was done on purpose.
Types are defined by a description of a set of
manipulations, as was done in the case of cooking
pots, type 1. If one treats the typology in this
way a much simpler typology emerges than that found
in Kenyon, 1965, Ch.4: The Iron Age Tombs. The two
lamps, Fig.259, 1 and 2, Tomb WHI are labelled
Types A1a and A2a, but they were definitely made in
exactly the same way. It cannot be demonstrated
that the difference between "rounded base" and
"base flattened and shaved", or "slight flange" and
"pronounced flange" is not accidental rather than
intended. Only if there is a noticeable tendency
through the phases toward "pronounced flange" may
one think of the coming of a new type. A type is
a fixed set of manipulations resulting in a shape
with a limited number of accidental variations.
These accidental variations are registered within
reasonable limits. However, the possibility al-
ways remains that certain elements are wrongly in-
terpreted as fortuitous or atypical, which were in
fact purposely done and therefore typical. The
material for comparative studies is found in
Kenyon 1965 and need not be repeated here.

33. BOWLS, TYPE 1; Fig.4:1-5

The wall is thin and the rim is not profiled.
An angle in the wall always indicates the use of a
rib on the lower half. Rounded walls are also
scarred with rib marks. The upper half of the wall
is wet-smoothed inside and outside. Usually the
angle with the base is larger than 90°, but some-
times less. The potter occasionally made the upper
part more vertical, thus accentuating the angle in

the wall. There is however an element of uncer-
tainty due to the fact that the amount of carbonate
in the clay varies considerably and with it the de-
gree of plasticity. If the clay happened to be
more plastic than usual, there was more shrinkage
during drying, causing the wall to erect itself
more than normally. The original wet shape was not
the same as the dried and fired shape.

 The rim was smoothed with a piece of leather or
other material. Usually these thin bowl rims are
fired to a uniform color right through the sherd,
but even here one sometimes finds a dark core.
The diameter averages ca. 18cm. These thin-walled
bowls are not frequent.

34. BOWLS, TYPE 2; Fig.4:6-9

 Here the walls are thicker. There is still no
profiling of the rim to speak of. Walls are round
or have a more or less pronounced angle. Depending
on how far the rib was used, the upper wall can be
shorter or longer.
 The rim, Fig.4:6 may have been kept short on
purpose. No's 7-9 show the upper wall pointing
outward or inward and slightly concave. No.9
shows the upward pressure on the rim between the
fingers on both sides. The concave shape of the
rim outside should not be confused with shapes such
as Fig.4:12,13. These rims were folded and thinned
by pulling the clay up.
The top of the rim may be round or flattened. The
diameter averages 20cm. with some larger bowls
(24cm.). No handles were found.

35. BOWLS, TYPE 3; Fig.4:10-13

 This type differs from the previous group in
that the folded rim was reshaped by pressing the
top of the rim down. Consequently, the top of the
rim is usually flat. Depending on the direction in

which the pressure was exerted, the clay was push-
ed to the inside (no.10), to the outside (no.11),
or to both sides (no.12). On the whole, the clay
was pushed to the outside. This can be considered
a routine treatment in this period. When the clay
was pushed down further on the outside a rounded
rim top is possible (no.13).

These bowls show the same treatment of scraping
below the upper wall and the diameter consistently
averages 28-30cm., with some smaller or larger
bowls (26-32cm.).

Three bowl fragments were found with bar-
handles (phases 13,12,10). No loop-handle was
found.

36. BOWLS, TYPE 4; Fig.4:14-17

Some of the rims are rather thin and may belong
to lamps. The wall is always bent out and the top
of the rim is mostly pushed out. This is a conti-
nuation of the tendency found in bowls, type 3.
The upper wall can be shorter or longer; this de-
pends on the way the rib was used, and on the
thickness of the wall.

The top of the rim is a broad, flat area. It
is possible that due to the thickness and degree
of plasticity, rims shrank and bent slightly in-
ward as in Fig.4:14,15. Then the flat top was
meant to be horizontal. There is a gradual tran-
sition to type 6. The diameter of these bowls
varies from 20-30cm.

37. BOWLS, TYPE 5; Fig.4:18,19

The rims of these bowls and lamps developed
from type 4. The thickened rim developed into a
flat, horizontal rim which is drawn until the
thickness equals the thickness of the wall. Some
show how quickly these bowls dried during the
treatment. While the rim was stretched, the clay

on the outside at the base of the rim contracted
in a very typical way, causing a rough surface
which was not wet-smoothed afterwards. This only
happens when the clay has become fairly dry. Be-
low the rim the treatment of these bowls is the
same as for the previous types. The diameter is
ca. 20cm.
For lamps, see section 24.

38. BOWLS, TYPE 6; Fig.4:20-22

The only difference between these bowls and
those of type 4 is that rims tend to become heavi-
er and walls are either vertical or slightly bent
inward. Morphologically they form a transition
between type 4 and type 9. The diameter varies
from 24-30cm., but is chiefly 25cm.

39. BOWLS, TYPE 7; Fig.4:23,24

These bowls or saucers have straight walls. The
rim was not made by turning up the end of the wall.
The rim is either round, or, when profiled, has
been flattened by pushing in the direction of the
wall (no.24). This is the type of rim found on
pedestal bowls or 'fruit bowls'. A few unstrati-
fied sherds showed that they were hand-made from
a cake of clay and that the surplus clay near the
base was scraped away with a rib (on the outside)
after the rim had become sufficiently dry to sup-
port the heavy clay base. Very few fragments were
found in this group. The diameter is ca. 25cm.,
one stratified sherd is 35cm. wide. They are not
burnished.

40. BOWLS, TYPE 8; Fig.4:25

This type differs from the previous type in
that the rim was turned up and profiled by folding

the end toward the inside or outside. The rim is
not higher than the thickness of the wall. These
bowls are scarce. The diameter is 32cm., one
sherd is 40cm. wide.

Fig.4:26 probably does not belong to this type,
although it is made in the same way. Only one
stratified sherd was found. The rim and the base
were profiled by scraping. After the application
of a slip, the mortar was carefully burnished.
This treatment, which deviates from the normal
pattern, points to the possibility that these
mortars were obtained by trade rather than being
locally made.

41. BOWLS, TYPE 9; Fig.5:1-4

Types 9 and 10 have the same rim shape. The
difference is in their sizes. Here it is supposed
that the smaller bowls (type 9) were made from one
roll of clay whereas the larger bowls were built
up in one or more coils added to the base. These
larger bowls have heavier rims (see Section 42).

The rims of type 9 are folded and triangular in
shape. Usually they are ring- or spiral burnished
inside and over the rim. Dry-scraping near the
base can cause an angle in the wall. The wall
near the rim was turned in a more vertical posi-
tion; this may have been accentuated by subsequent
shrinkage. The result is sometimes an inverted
upper part of the rim. This in turn may accentu-
ate the 'kink' in the wall. One finds rim sherds
with handles. Handles make ring-burnishing on the
outside impossible. Probably a red slip was ap-
plied more often than can be observed without re-
firing the sherds.

The rims have been divided into three shapes,
which probably were intended by the potters.
Type 9a

The folded rim projects from the wall.
Type 9b

The rim has been smoothed flat against the wall

on the outside.
Type 9c
 The side of the rim is bent inward and is more
horizontal. This may accentuate an inward direc-
tion of the upper part of the wall, and thus make
the bowl look like a different type.

42. BOWLS, TYPE 10; Fig.5:5-12

 These bowls are larger than bowls, type 9, and
presumably were made in coils. Usually the rim is
heavy. The top of the last coil was folded to the
inside, where surplus clay was disposed of by
smearing it out. Then the new rim top was folded
to the outside and the new shape was slightly re-
worked. Ring- or spiral burnishing was often done
before the entire inside was leather-hard. The
use of a slip cannot always be established. But
in the clear instances the slip was painted with a
brush. The average diameter is ca. 40cm.
 There are broad folded and pulled handles. The
lower end of the handles was probably attached to
the pot with the aid of some extra clay.
 The final shape of the rim depends on two fea-
tures of the routine treatment. (a) How much clay
of the last coil was folded back, and (b) how this
influenced the final treatment of the rim. Bowls,
type 10 falls roughly into eight groups.
Type 10a
 The top of the rim is slightly bent to the in-
side and is lower than the highest part; the sec-
ond fold ends abruptly sideways against the out-
side of the wall (no.5).
Type 10b
 The top of the rim is made flat and horizontal
(no.6).
Type 10c
 The top of the rim is round and wider than the
wall on both sides (no.7).
Type 10d
 The top of the rim is pointed and the inside is

in a straight line with the wall (no.8).
Type 10e

The top of the rim is pointed and the inside is
in a straight line with the wall. The outside
fold is smoothed out against the wall (no.9).
Type 10f

The rim is made like type 10e, but the top is
bent to the inside (no.10).
Type 10g

The rim is almost vertical but slightly in-
clined. It has an equal thickness in section
(no.11).
Type 10h

The rim is made like type 10a, but it forms a
distinct angle to the wall (no.12).

The division of sub-types is not hard and fast.
This division can be made because most rims clus-
ter around these eight shapes. The differences in
the final treatment and the amount of clay from
the last coil resulted in these eight groups.
There is a possibility that some of these groups
will reveal a tendency of development.

43. BOWLS, TYPE 11; Fig.5:13

This broad and thick rim which is not horizon-
tal probably belongs to deep bowls resembling
bowls, type 10.
There are three differences however.
a. It seems that these bowls are deeper than
 bowls, type 10,
b. They are not completely burnished on the in-
 side, but rather on the outside and only near
 the rim inside,
c. There is a characteristic groove separating the
 rim from the wall outside. This groove was not
 made with a tool. It marks the second fold
 (to the outside). The diameter of the rim
 measured from the highest point on the circum-
ference is usually 30cm., and sometimes as much as
40cm.

This rim usually makes a sharp angle to the
wall. The same kind of subdivision can be made as
was done with bowls, type 10, but there are not
enough rims - only twenty-seven - to find clusters
which point to regular patterns.

44. BOWLS, TYPE 12; Fig.5:14

This rim may belong to the previous group and
not be a separate type. The characteristic groove
of type 11 has been smoothed away, and the rim is
more vertical. Only five sherds were found.

45. BOWLS, TYPE 13; Fig.5:15

This rim is broad, thick and flat, but not al-
ways horizontal, and has a uniform thickness in
section. The end of the second fold was accentu-
ated by the potter who held a finger against it
while the pot turned. The shape of the pot was
probably cylindrical.
The entire inside of these pots from a point on
the circumference of the rim is bluish black. The
exterior is red. This is an indication that the
pots were stacked on top of each other in the kiln.
The pot on top closed the mouth of the vessel be-
neath, thus cutting off the oxygen flow and re-
sulting in a reducing atmosphere inside the vessel.
Only four stratified sherds were found.

46. BOWLS, TYPE 14; Fig.5:16

These deep bowls may belong to type 13. The
potters accentuated the second fold by pushing up
the end of it and pinching the rim just beside
this end. This treatment offers possibilities of
making various rim profiles. Only five stratified
sherds were found.
It may be purely coincidental that no sherds of

of types 12-14 were found earlier than phase 13,
because in all there are only fourteen sherds of
these types.

47. BOWLS, TYPE 15; Fig.5:17

 Types 10-14 are large bowls with very heavy
rims. Type 15 is a group of apparently large
bowls with small, folded rims. The bowls were not
thrown.
 The upper part of the wall is more or less ver-
tical, with a slight curve to the inside. They
were not stacked on top of each other in the kiln.
The rim is flattened or rounded, protruding to the
inside and/or outside. Only ten stratified sherds
were found from phases 19-6. The diameter is
usually ca. 25cm. with some smaller. The bowls
were not burnished.

48. BOWLS, TYPE 16; Fig.5:18

 Type 16 is a larger group of bowls than type
15. Though similar to type 15 the rims are
heavier. The upper part of the wall is rounded
and curved inward. Sometimes it seems that the
rim is folded twice to the outside. The diameter
is usually 30cm., a few sherds are smaller.
These bowls are not burnished.

49. BOWLS, TYPE 17; Fig.5:19

 The rims of this type were made horizontal,
broad and flat by attaching only part of the fold
to the wall and turning the rim further over the
inside. The wall is rounded and curves inward.
Once a handle is found. These bowls may have been
smaller than the previous types. They are some-
times burnished.
 Sporadically other shapes like craters occur.

Such shapes have been included in the survey of
the phases.

No bowls were found that were undoubtably
thrown. This miscellaneous group may contain some
Transjordanian shapes.

50. JARS - INTRODUCTION

The jar rims are classified into rims of large
and small jars. The rims of the large jars are
divided into two groups, (a) rims descending from
the Iron Age I jars, and (b) rims stemming from a
different tradition.

Small jars can be thrown long before large
jars; that is to say, the circumference of a small
jar or juglet is so much smaller than that of a
large jar that it turns slowly even when placed on
a wheel that rotates with some speed. Of course,
how throwing is defined determines whether one
calls these juglets thrown or not. If throwing
always presupposes a good plastic clay, then most
of the juglets were not thrown but turned. They
were however made from the cone while the wheel
was kept turning until the juglet was finished.
See section 24 and Fig.1:17-19. It could not be
determined whether some of the juglets were indeed
thrown.

The large jars from the Iron Age I tradition
were built in coils and turned (types 1-3). It is
supposed that at least some of the sherds found in
the other groups (types 4-6) belong to thrown
jars. A good deal of body sherds is necessary to
make this more certain.

Only two sherds were analyzed for temper iden-
tification (see Section 15). One from the hand-
made group (types 1-3) is not from Jericho, and
may have come from Transjordan. One from type 4
has no temper. This sherd may also be foreign;
this cannot be verified without more analysis.
One would expect fine quartz temper in the wheel-
thrown pottery if it came from the same center as

the wheel-thrown cooking pots. But the fact that
the sherd has been fired near the maturing range
points to a different composition and method of
firing, since, as we have seen, the Jericho pot-
tery is bound to disintegrate before the vitrifi-
cation point is reached.

51. JARS, TYPE 1; Fig.6:1

 The rim is folded. Below the rim is a ridge on
the outside which usually corresponds to a hollow
on the inside. This ridge can typologically be
distinguished from the band around the neck, which
is characteristic for type 2.
 The evidence from Deir CAllā (Franken & Kals-
beek, 1969 (5)) shows that the situation is rather
complicated. There we find quite definitely two
traditions. Deir CAllā, type 1c-g resembles
Jericho, type 1 and Deir CAllā, type 1h-l resem-
bles Jericho, type 2. The stratigraphy clearly
points to the introduction of type 1h-l at Deir
CAllā and the replacement of type 1c-g by type
1h-l. In other words, type 1h-l was made else-
where before it was introduced at Deir CAllā.
Type 1c-g was then no longer made. But one of the
variants of type 1h-l, variant k, developed until
it resembled type 1e again.
 One may be right in arguing that Jericho, type
1 and 2 are indeed one type, 1 being a variant of
2. However, it is very well possible, and indeed
likely, that Deir CAllā, type 1c-g did not dis-
appear after it had been introduced on the West
Bank and that it was made there until the 7th
century B.C. We have two jar types, made east of
the Jordan in the 13th century B.C., which were
brought to Palestine in the 12th century B.C.
where they replaced the Late Bronze jars and which
are called Iron Age I in the archaeological termi-
nology. They both stem from one stream of tradi-
tion not related to the Palestinian Late Bronze
tradition. More must be known about the history

of the two types in the Iron Age before it can be
decided what their relationship was in the 7th
century B.C.

52. JARS, TYPE 2; Fig.6:2

Type 2 has been singled out although there are
only six stratified sherds, because it was defini-
tely once a type. Instead of a ridge around the
neck it has a broad band below the rim, but there
is always the corresponding hollow on the inside
of the neck. It is just possible that type 1 al-
ways existed beside type 2 in Palestine. Another
possibility is therefore that the six sherds of
type 2 came from across the Jordan.

53. JARS, TYPE 3; Fig.6:3-5

A development of shape took place when the pot-
ters began to make a shorter neck and to bring
ridge and rim close together. It sometimes looks
as if the rim is attached to the shoulder (no.3).
Eighteen sherds were found, fairly evenly distri-
buted through the phases.

54. JARS, TYPE 4 and 5; Fig.6:6-10

Type 4 may encompass a number of different jar
shapes, but from the rim only further divisions
cannot be made because they are all made in the
same way. Some have a fairly coarse grit, but of-
ten the grit is very fine and invisible; probably
even non-existent, as in the test-sherd. The size
of the grit influences the color. The red is
darker than in types 1-3, and sometimes it seems
that the sherd was fired near vitrification, re-
sulting in a whitish color.
Clay 'drops' in the neck point to a method of
turning or throwing the base closed. As the base

was being thrown closed upside down, clay dripped
from the base to the neck.

Few rims show traces of having been worked in
a fairly dry state, but the majority were worked
wet.

The method of folding the rim in order to get
rid of the surplus clay was not found in this
group. The thickened rims were made in a quick
turning movement like throwing.

There is one more rather important feature
which points to throwing. The break lines are not
perpendicular to the rim but oblique. This con-
trasts sharply to types 1-3 where the break is
vertical and horizontal. At least this shows that
turning was much faster for these jars than for
types 1-3. In contrast to the bowls we find here
a type of pottery which looks like thrown pottery.
Further evidence is needed to decide whether they
were made at Jericho or not.

No attempt was done to subdivide the rims.
Few sherds with exceptionally long necks were
found. They were classified under type 5.

55. JARS, TYPE 6; Fig.6:11-13

Type 6 may belong to a different shape because
of the rather short neck. The unprofiled rim
(no.11) is sometimes found and is suspected to
have been brought from elsewhere. There is less
carbonate in the clay than usual.

56. JARS, TYPE 7; Fig.6:14,15

Only four sherds were found. They have a broad
and flat rim top. The clay is pushed over the
outside and flattened. One recognizes these rims
as belonging to a group of deep vessels with three
handles near the rim, on which the fourth handle
is replaced by a cup.

57. JARS, TYPE 8; Fig.6:20-22

This type comprises the pilgrim flasks and
fragments of long and narrow necks. These long,
narrow necks were separately made or turned with
the entire body of the juglet.

Only from a proper analysis of the tempering
materials can one make a distinction between
throwing and turning, provided the body sherds
could be examined. In the survey of the pottery
found in the phases, these sherds have all been
drawn.

58. JARS, TYPE 9; Fig.6:16-19

This is the group of small juglets and dippers
with short necks. There is not enough stratified
material to make a proper division, although some
shapes may be compared to well-known complete
shapes. Structurally there is very little varia-
tion. Shapes however can vary greatly because
these juglets offer few problems compared to larg-
er shapes. Hence there are many possible combina-
tions of necks and rims with body-shapes.

59. THE MODELS

The Iron Age II pottery repertoires found at
Jericho contain pottery from several traditions.
The bulk of the material consists of coiled and
turned pottery. We assume that most of it was
locally made. It all stems from the Iron Age I
tradition but some of it comes from a Transjorda-
nian branch or branches. The origin of the Iron
Age I tradition is unknown. It is impossible to
consider this tradition as a straight descendant
of the Late Bronze tradition in Palestine.

The Iron Age II cooking pot is not a descendant
of the Iron Age I cooking pot; both came from
Transjordan and are found in Deir ᶜAllā in the

12th century B.C. They may have a common origin
but when they turn up at the beginning of the Iron
Age they have distinctly different models.

These models are different again from that of
the Iron Age I tradition. A construction drawing
of the cooking pot that first came to Palestine
(see Fig.20) is made from a large amount of sherds
found at Deir ^CAllā. Some basic elements of the
construction of pottery in the Iron Age I tradi-
tion are represented by the construction drawing
of a large bowl from Deir ^CAllā (see Figs.21,22).
Such drawings cannot be made for the pottery types
of the 7th century B.C. from Jericho. The treat-
ments of the rims are known but not those of the
bases and walls of the pots in connection with the
different rim types.

60. LIST OF PHASES

List of Phases used in this Report	Description	Phase Numbers
25 = 0	Silt	lxvi
24 = N	Rubble	lxvii
23 = Ni	Occupation	lxviia
22 = M		
21 = L	First building	lxviii
20 = Li	Occupation	lxviiia
19 = Lii	Occupation	lxviiib
18 = K		
17 = Ki	Second building	lxix
16 = Kii	Fill	lxviii-lxix
15 = J		lxix
14 == H,Hii	Fill	lxx-lxxi
13 = G		lxix
12 = Gii	Occupation	lxixa
11 = F	Destruction	lxix-lxx
10 = H	Fill	lxx-lxxi
9 = Hi,Fii		lxxi

List of Phases (continued)	Description	Phase Numbers
8 = E	Walls round foot of tell	lxxii
7 == F		lxix-lxx
6 == E		lxxii
5 = Eii	Destruction	lxxii-lxxiiia
4 = Eiii	Collapse debris	lxxii-lxxiiib

Fig.23, a drawing of part of the North side of Trench I , is taken from the Palestine Exploration Quarterly 1956, p.70 (opposite). I have added the phase numbers. It shows the Iron Age occupation levels to which the following description refers, West of the "Hyksos" retaining and defence wall.

61. DESCRIPTION OF THE STRATIGRAPHY
 by Dr. K.M. Kenyon

The phase lxvi deposit represents a prolonged period of wash and silt. On the slope of the mound, this is pinkish and rather stony. It gradually becomes browner and more silty, and in the level area at the west end it is a very fine compact silt with horizontal striations. It is clearly an entirely natural accumulation produced by gentle erosion from rain wash of the surface of the mound.
STAGE XLV
Phases lxvii and lxvii a
On the level area at the foot of the mound, there now appears a fill which seems to be an intentional levelling up, for there are a series of tip lines from west to east. One would expect this to be a preparation for some building, but there are no structural features in the area excavated. Above it there are in fact in phase lxviia occupation layers, including a fireplace, so there may have been a building near by.

The phase ends with a considerable ash layer
coming down the slope, again suggestive of build-
ings in adjacent areas that were destroyed by
fire.

STAGE XLVI

Phase lxviii

Above the final burnt layer of phase lxviia
appears the first definite Iron Age building in
the area, set in the level ground at the foot of
the mound, slightly askew to its general orienta-
tion. It was a rather flimsy building, with
slender walls, one course thick, of soft bricks.
Excavation was only carried to the depth of this
building in the original trench. Its successor,
of phase lxix, which was excavated over a wider
area, was in the same orientation with wall LH
overlying wall LA and wall LB of phase lxviii
continuing in use in phase lxix, as can be seen in
the north section. The east wall of the phase
lxviii building, LD, was, however, west of the
later one. The westernmost wall, LC, of the ear-
lier building was not re-used. It can be surmised
that in general the buildings were similar.

There were two series of occupation levels
within the building, in the second of which there
was a silo with clay walls set on a brick plat-
form.

The building was destroyed by fire, the debris
from which was incorporated in the raised level of
phase lxix. Not much of this is in situ in the
north section, but on the south side of the trench
the undisturbed debris was cut into by the new
foundations to a depth of 1.75m.

STAGE XLVI

Phase lxix

The second Iron Age building was a massive
affair with walls a metre wide, of well-bonded
bricks, mainly in courses of headers on one face
and stretchers on the other. The foundations were
carried down at least 1.50m. below the ultimate
floor level, unless, as in the case of wall LH,
they rested on earlier walls. As has been already

mentioned, these foundations in part cut through
the destruction debris of the previous phase, and
were in part free-built with a filling to floor
level subsequently added, as can be seen in the
north section. The average size of the bricks was
53x30x14cms.

The building is well-built and spacious. The
plan suggests the tripartite arrangement, with a
fourth room at right angles, which is very common
in Iron Age II. It is however possible that the
southern range was an addition, since the walls do
not bond into wall LH. Nothing in the occupation
layers was of especial significance. The house
may have been an ordinary private dwelling rather
particularly well built.

STAGE XLVI

Phases lxix-lxx to lxxi

The phase lxix building was destroyed by fire,
the evidence for which was preserved to a consid-
erably greater degree to the north than that shown
on the main section line.

In phase lxx, this was followed by the removal
by robbing or erosion of a considerable part of
the building. The walls at the east end survive
to just above floor level. The section shows that
to the west both the foundations of the walls and
the make-up of the floor have been removed in a
great bite sloping down to the west. Since mud
brick walls are not worth robbing for the re-use
of the materials, this is likely to be the result
of severe erosion.

Subsequently, the resultant hollow was filled
up, with tip lines running down from west to east,
being therefore an intentional operation, to a
height just above that of the phase lxviii floor.

In phase lxxi, there were some occupation above
this fill, including some pits, one of which is
visible in the north section. There were, however,
no buildings in the excavated area.

STAGE XLVII

Phase lxxii

The next phase is represented by two walls LM

and LN, which resume the orientation parallel to
the lines of the mound which had existed at all
periods preceding phase lxviii. There was at
least one cross wall, LO, joining them. In wall
LM there were two doorways. That north of wall
LO was found filled with broken bricks, that in
the southern compartment was filled with burnt
material. Wall LM in this southern compartment
had in the brickwork a slot filled with soft mate-
rial which presumably originally held a timber,
from its width either upright planks set edge to
edge, or a horizontal plank on edge; either method
of employing timbers is rare, if not unique. Adja-
cent to wall LO, was a more normal timber socket
25cms. square; the continuous slot was interrupted
at this point. Two sizes of bricks were used,
40x40x12cms. and 60x40x12cms.

A double line of wall with a linking cross wall
surrounding the edge of a settlement suggests a
defensive wall on the casemate system. Though the
upper level of a casemate wall may contain rooms,
the strength of the wall depends on deep founda-
tions with a solid fill between, thus providing
the equivalent of a thick wall with minimum la-
bour. These flimsy walls were virtually at the
level of the plain outside, and their foundations
are very slight. The enclosed rooms were also too
large for the cross wall to have added strength.

The structure cannot, therefore, have been de-
fensive, but it may have served to enclose the
mound, perhaps to keep flocks and herds in at
night. The enclosed areas may indeed even have
been pens, though the amount of large burnt tim-
bers in the destruction debris seems rather great
to have come from the wall timbers, and suggests
that the compartments were roofed.

The evidence of occupation of the building is
a thickish layer of water-laid silt on the up-hill
side of the building, and some slight occupation
levels within it.

Above the layer containing many burnt timbers
was a spread of yellow brick debris derived from

the upper part of the walls.
STAGE XLVIII
Phase lxxiii
 Phase lxxii is the final Iron Age building in
this area, and probably marks the end of the Iron
Age occupation of the site. Above the collapse
debris, filling in its hollows, and tailing off up
the slope to the east was a thick horizontally
laminated silt level, with striations of fine
grit. This clearly represents winter rain-wash
settling in hollows at the foot of the mound dur-
ing a long period when there was little to disturb
the surface of the mound. It contains very many
fragments of Iron Age pottery, showing that this
was the material that was lying on the surface of
the mound during this period.

Chart 1, Color Test

a. before refiring, b. after refiring

		Outside	Inside	Core
1.	Base type 2	a. 10YR 7/4, very light brown	10YR 7/4, very light brown	N5, grey
		b. 10YR 8/6, yellow	10YR 8/6, yellow	2.5YR 5/8, red
2.	Cooking pot type 12	a. 10R 4/6, red	10R 4/6, red	10R 4/8, red
		b. 10R 4/4, weak red	10R 4/4, weak red	10R 4/6, red
3.	Base, bowl section 31	a. 2.5YR 5/6, red	10YR 7/3, very pale brown	10YR 7/3, very pale brown
		b. 10R 5/8, red	10YR 8/3, very pale brown	10YR 8/3, very pale brown
4.	Cooking pot type 1	a. 10R 5/6, red	10R 5/6, red	5YR 4/8, yellowish red
		b. 10R 5/6, red	10R 4/6, red	10R 4/8, red
5.	Base type 1	a. 2.5YR 6/6, light red	10R 4/8, red	2.5YR 6/6, light red
		b. 2.5YR 5/6, red	10R 4/6, red	2.5YR 5/6, red
6.	Base type 2	a. 10YR 4/1, dark grey	2.5YR 5/4, reddish brown	10YR 4/1, dark grey
		b. 2.5YR 6/4, light reddish brown	2.5YR 5/8, red	2.5YR 5/8, red
7.	Base type 2	a. 10YR 6/2, light brownish grey	10YR 4/1, dark grey	10YR 4/1, dark grey
		b. 5YR 7/4, pink	5YR 7/4, pink	5YR 7/4, pink
8.	Base type 2	a. 10YR 8/3, very pale brown	10YR 7/2, light grey	10YR 7/2, light grey
		b. 10YR 8/3, very pale brown	10YR 7/2, light grey	7.5YR 8/6, reddish yellow
9.	Jar type 9	a. 2.5YR 5/8, red	5YR 6/4, light reddish brown	5YR 6/4, light reddish brown
		b. 2.5YR 6/8, light red	2.5YR 6/8, light red	2.5YR 6/8, light red
10.	Body sherd	a. 7.5YR 7/4, pink	7.5YR 5/4, brown	7.5YR 5/4, brown
		b. 7.5YR 8/6, reddish yellow	7.5YR 6/6, reddish yellow	7.5YR 6/6, reddish yellow
11.	Cooking pot type 1	a. 10YR 4/1, dark grey	5YR 2/1, black	5YR 2/1, black
		b. 2.5YR 5/8, red	10R 5/6, red	10R 4/8, red
12.	Base type 2	a. 5YR 5/6, yellowish red	10YR 5/3, brown	10YR 5/2, greyish brown
		b. 2.5YR 6/8, light red	2.5YR 6/8, light red	2.5YR 6/8, light red

Chart 1, continued

	Outside	Inside	Core
13. Base type 2	a. 2.5Y 7/2, light grey b. 10YR 8/2, white	10YR 6/3, pale brown 5YR 8/4, pink	10YR 6/3, pale brown 5YR 8/4, pink
14. Cooking pot type 6	a. 5YR 4/2, dark reddish grey b. 10R 5/3, weak red	5YR 5/4, reddish brown 10R 4/6, red	7.5YR 3/2, dark brown 10R 4/8, red
15. Cooking pot type 1	a. 2.5YR 5/4, reddish brown b. 10R 6/6, light red	2.5YR 5/8, red 10R 5/8, red	2.5YR N4, dark grey 10R 6/6, light red
16. Bowl type 10	a. 2.5YR 5/4, reddish brown b. 2.5YR 6/6, light red	5YR 5/3, reddish brown 2.5YR 6/6, light red	2.5YR N5, grey 2.5YR 4/8, red
17. Bowl type 10	a. 7.5YR 6/4, light brown b. 2.5YR 5/6, red	7.5YR 6/4, light brown 5YR 6/6, reddish yellow	7.5YR 6/6, reddish yellow 5YR 6/6, reddish yellow
18. Bowl type 13	a. 7.5YR 6/4, light brown b. 5YR 8/4, pink	10YR 5/2, greyish brown 5YR 7/4, pink	10YR 5/2, greyish brown 5YR 7/4, pink
19. Base M.B.	a. 2.5Y 7/2, light grey b. 2.5Y 8/2, white (slip)	5YR 6/3, light reddish brown 2.5YR 6/8, light red	2.5Y 6/1, grey 2.5YR 6/8, light red
20. Base type 2	a. 2.5YR 6/4, light reddish brown b. 7.5YR 8/4, pink	10YR 7/3, very pale brown 5YR 7/4, pink	10YR 5/1, grey 5YR 7/4, pink
21. Base type 1	a. 10YR 7/3, very pale brown b. 10YR 8/3, very pale brown	7.5YR 7/3, very pale brown 5YR 7/6, reddish yellow	10YR 6/3, pale brown 10YR 8/3, very pale brown
22. Base type 2	a. 2.5YR 6/6, light red b. 2.5YR 6/4, l. reddish br. (slip)	2.5YR 5/8, red 2.5YR 5/8, red	10YR 5/1, grey 2.5YR 5/6, red
23. Base type 2	a. 2.5Y 8/2, white b. 10YR 8/3, v. pale brown (slip)	5YR 6/3, light reddish brown 5YR 7/6, reddish yellow	5YR 5/1, grey 5YR 7/6, reddish yellow
24. Jar	a. 10YR 8/3, very pale brown b. 10YR 8/3, very pale brown	7.5YR 7/4, pink 5YR 7/4, pink	5YR 6/4, light reddish brown 5YR 7/4, pink

Chart 1. continued

		Outside	Inside	Core
25. Bowl type 9	a.	10R 4/8, red (slip)	2.5YR 5/6, red	2.5Y N6, grey
	b.	7.5R 3/8, red (slip)	2.5YR 4/6, red	2.5YR 6/8, light red
26. Bowl section 31	a.	10YR 7/6, very pale brown	7.5YR 7/4, pink	7.5YR 6/4, light brown
	b.	10YR 8/4, very pale brown	5YR 6/6, reddish yellow	5YR 6/6, reddish yellow
27. Bowl type 10	a.	10YR 7/4, very pale brown	10YR 5/3, brown	10YR 6/2, light brownish grey
	b.	10YR 7/4, very pale brown	5YR 7/6, reddish yellow	5YR 6/6, reddish yellow
28. Bowl type 9	a.	10R 6/6, light red	10R 5/6, red	10YR 5/3, brown
	b.	10R 6/6, light red	10R 5/6, red	2.5YR 6/8, light red
29. Jar type 1	a.	10R 4/3, weak red	10R 4/3, weak red	10R 5/8, red
	b.	7.5R 5/4, weak red	10R 5/6, red	10R 5/6, red
30. Body sherd	a.	5Y 5/1, grey	5Y 7/3, pale yellow	N5, grey
	b.	5YR 7/4, pink	5YR 7/6, reddish yellow	5YR 7/6, reddish yellow
31. Jar	a.	10YR 7/3, very pale brown	7.5YR 7/2, pinkish grey	7.5YR 7/2, pinkish grey
	b.	7.5YR 7/4, pink	5YR 7/4, pink	5YR 7/4, pink
32. Disintegrated	a.	5YR 7/3, pink	2.5YR 6/6, light red	2.5YR 5/2, greyish brown
	b.	10R 6/6, light red	2.5YR 6/6, light red	2.5YR 6/6, light red
33. Base type 2	a.	10YR 6/3, pale brown	10YR 5/2, greyish brown	10YR 5/2, greyish brown
	b.	5YR 7/4, pink	5YR 6/4, light reddish brown	5YR 6/4, light reddish brown
34. Body sherd	a.	10YR 6/3, pale brown	10YR 7/3, very pale brown	10YR 7/3, very pale brown
	b.	10YR 6/3, pale brown	10YR 7/3, very pale brown	10YR 7/3, very pale brown
35. Bowl type 10	a.	5YR 7/6, reddish yellow	5YR 6/3, light reddish brown	7.5YR N5, grey
	b.	5YR 7/6, reddish yellow	5YR 6/6, reddish yellow	5YR 7/6, reddish yellow
36. Bowl type 12	a.	10R 6/6, light red	10R 6/6, light red	10R 5/2, weak red
	b.	10R 6/6, light red	10R 6/8, light red	10R 6/6, light red
37. Bowl type 13	a.	5YR 6/8, reddish-yellow	5YR 4/4, reddish brown	5YR 6/6, reddish yellow
	b.	2.5YR 5/8, red	10R 4/8, red	2.5YR 6/8, light red

Chart 2, Cooking Pots

The numbers to the left indicate the number of drawn sherds,
the numbers to the right indicate the number of undrawn sherds

Types	24	23	22	21	20	19	16	15	14	13	12	11	10	8	7	6	5	Total
1a	2 1	1	4 6	1 3		1 4	6 8	1 3	3 9	5 21	2 1	5 7	3 15	1 3	4 4	1 1	1 2	128
Handles 1a			(4)	(1)		(3)	(4)	(1)	(11)	(6)	(1)	(8)	(12)	(2)	(1)	(1)	(2)	(57)
1b	1		1 5	2	1	2 2	1 1		1		1	2 2	2 1	1				26
Handles 1b			(3)				(1)											(4)
2	1					1				1		1						4
3				1	1	1				1		1						5
4			1	1	1				1 1	1					1			7
5			1 1			2 1			3	2	1	3	1	2	1		1	19
6						1								1				2
7																	1	1
8			1															1
9													1					1
10			1	1								2	1	1				6
11									1			3						4
12								1	1			2		1	1			6
Total	5	1	21	9	3	15	16	5	20	31	5	28	24	9	12	1	5	210

Chart 3, Bowls

The numbers to the left indicate the number of drawn sherds,
the numbers to the right indicate the number of undrawn sherds

Types	24	23	22	21	20	19	18	17	16	15
1	1	1	1	1			1 1		1	1
2				1 4		1	1		1 4	
3	1		3 5	1 1	1	1 3	1 1		1 2	
4		1	3 3	1 3	1	1 1			1 1	
5			1			1				
6			2						1	1
7	1		1 1	1 2		1				1
8						1	1			
9 a-c	1		1	1				1	2 2	1 2
10 a-h	2		5 4	2 1		1	2 1		2 4	1 2
11	1		2 3		1	1				
12										
13										
14										
15						1				1
16			4	2		1			1	1
17				2					1	
Total	7	2	39	23	3	14	9	1	24	11

Chart 3, Bowls (continued)

Types	Phases									Total
	14	13	12	11	10	8	7	6	5	
1	1	1	1 1	2 2	1 2					19
2	1	1 2	2 1	1 6	2 5		1 1	1		36
3	1	2 2	1 1	2 1	2 1		1 1			36
4		1 8		3 5	1 4	1			1	40
5				2 3	1		1		1	10
6	1	1			2 3		1 2	1	1 1	17
7		1			1 1		2			13
8		2		1	3			2	1	11
9 a-c	2 1	5 7	1 1	4 5	3 10	1 1	2 6	1	2 3	66
10 a-h	2 2	6 19	1	6 29	6 26	1 5	3 5	2 3	3 7	153
11	1	2 5	1	2 3	1			1	2 1	27
12		1						1	1 2[+]	5
13				1	1			2		4
14				1	2				1 1	5
15	1	1 1		1		1 1		1 1		10
16	1	1 2	2	1 4	2 8	2	1		1 1	35
17		1 1	1	2 2	1			1	1	13
Total	14	73	14	89	89	13	27	17	31	500

[+]Possibly Type 10

Chart 4, Jars

The numbers to the left indicate the number of drawn sherds,
the numbers to the right indicate the number of undrawn sherds

Types	24	23	22	21	19	18	17	16	15	14	13	12	11	10	7	6	5	Total
1	1 2		4 2	1 3	2 4			2 3			4 10	1 2	2 15	1 3	2	2	1	67
2			1									1	1 1	1			1	6
3			1 1	1	1 1			1 1		1	1 3	2 1	1 1	1 1		1	1	18
4		1	1 1	1	1 1		1 1	2		2 3	3 3	1	7 17	1 3	1 1	4 4	2 4	61
5									1 1						1			4
6							1 1	1 2			1 7		2 3	1 1			1	21
7								1								1 1		4
8			1			1				2			3	1	2	3	4	17
9			3					1		6	4		3	4	4		1	28
Total	3	1	15	6	10	1	1	14	1	13	36	8	56	18	11	17	15	226

Phases

Chart 5, Bases

The numbers to the left indicate the number of drawn sherds,
the numbers to the right indicate the number of undrawn sherds

Types	24	22	14	13	Phases 12	11	10	7	6	5	Total
1					1	1					2
2	1							1	1		3
3			5 5	3 3		2	1 3	2 1	2 2	1 1	31
4			1								1
5						1		1 1	1		4
6	1	1		1 3		1 1		1			9
Total	2	1	11	10	1	6	4	7	6	2	50

Chart 6, Handles

Types	14	Phases 11	10	7	Total
1	1		1	1	3
2	1			1	2
3	1	1		1	3
Total	3	1	1	3	8

Chart 7, Bowls; coarse and fine temper

Types	24-17		16-10		9 - 5		Total	
	c	f	c	f	c	f	c	f
1	5	1	6	7			11	8
2	4	3	21	5	3		28	8
3	17	1	11	5	1	1	29	7
4	10	4	11	13	1	1	22	18
5	1	1	3	3	2		6	4
6	2		7	2	5	1	14	3
7	3	4	3	1		2	6	7
8	2		5	1	2	1	9	2
9	3	1	41	5	11	5	55	11
10	16	2	75	31	19	10	110	43

(Header spanning "Phases" over 24-17, 16-10, 9-5)

In bowls, types 11-17 only coarse temper was observed

Chart 8, Jars; coarse and fine temper

Types	24-17		16-10		9 - 5		Total	
	c	f	c	f	c	f	c	f
4	5	1	25	14	10	6	40	21
5				2	1	1	1	3
6	2		16	2	1		19	2
7				2		2		4
8	2		4	2	2	7	8	9

(Header spanning "Phases" over 24-17, 16-10, 9-5)

Jars, types 1-3 had only coarse temper

Chart 9, Bowls; burnishing and slip
U= unburnished, I/0= burnished inside and outside,
I= burnished inside, S= slip

Types	24-17				Phases 16-10				9 - 5			
	U	I/0	I	S	U	I/0	I	S	U	I/0	I	S
1	3		3	1	11	2		2				
2	4	1	2	2	19	3	4	9	?	?	?	?
3	13	3	2	7	9	5	2	7	2			1
4	7	1	5	3	11	5	8	11	1		1	1
5	2				5		1		1		1	1
6			2		5		4	5	1		1	1
7	7				4			1	2			
8	2				6				3			
9	2		2	2	8		39	12			16	
10	1		17	1	2		104	1	1		28	1
11	4	2	1	2	14		1	1	3			
12					1						3	
13					2				2			
14					3				2			
15	1				5				4			
16	6		1		20		3		5			
Total	52	7	35	18	135	15	166	49	29		50	5

Chart 10, distribution of the white-firing bowls

Types	22	21	Phases 16	15	13	11	10	7	Total
2			1			2	3		6
3								1	1
4					1		3		4
6				1			2		3
9	1	1			2	2	2		8
10						1	1		2
Total	1	1	1	1	3	5	11	1	24

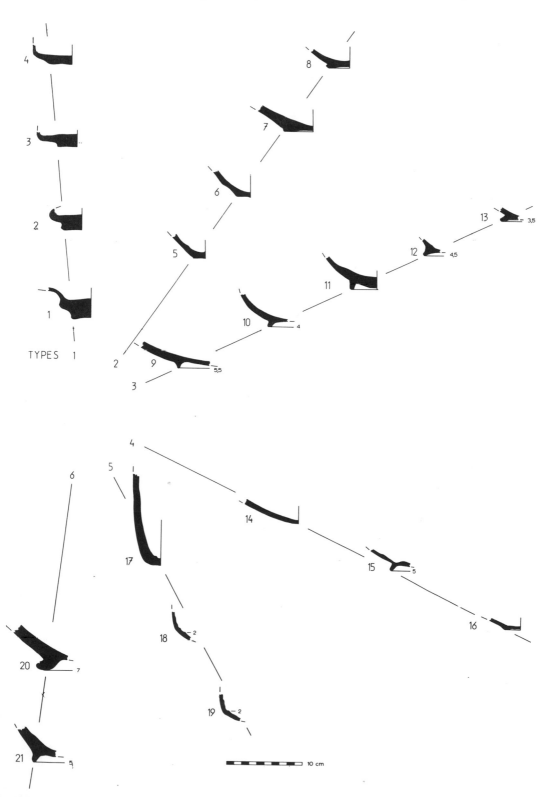

Figure 2, Handles

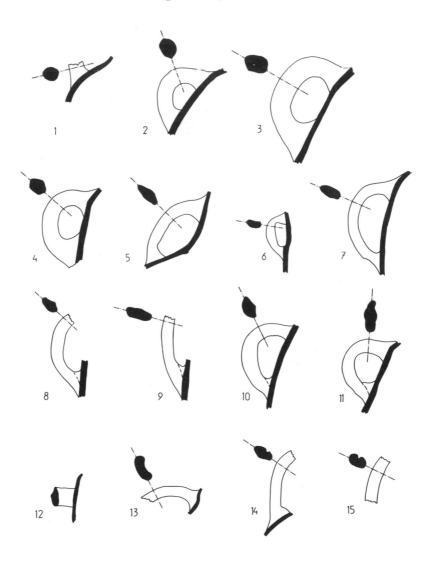

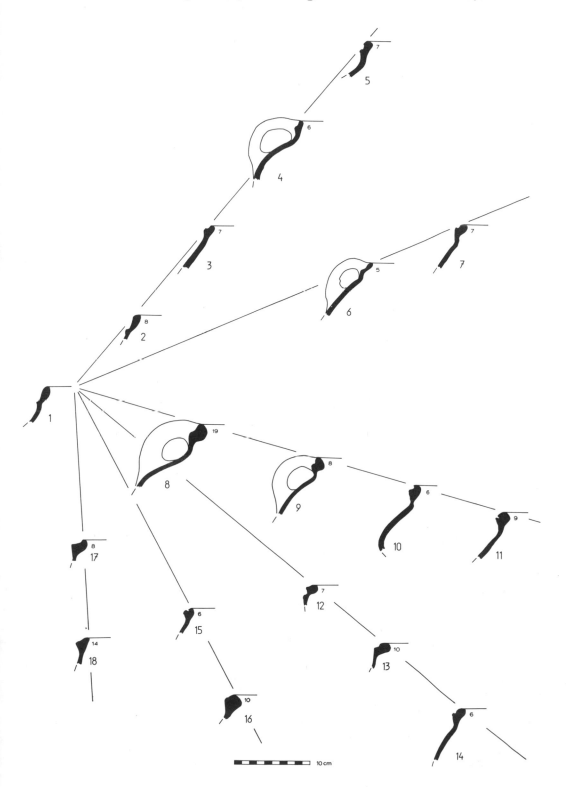

Figure 4, Bowls, Types 1-8

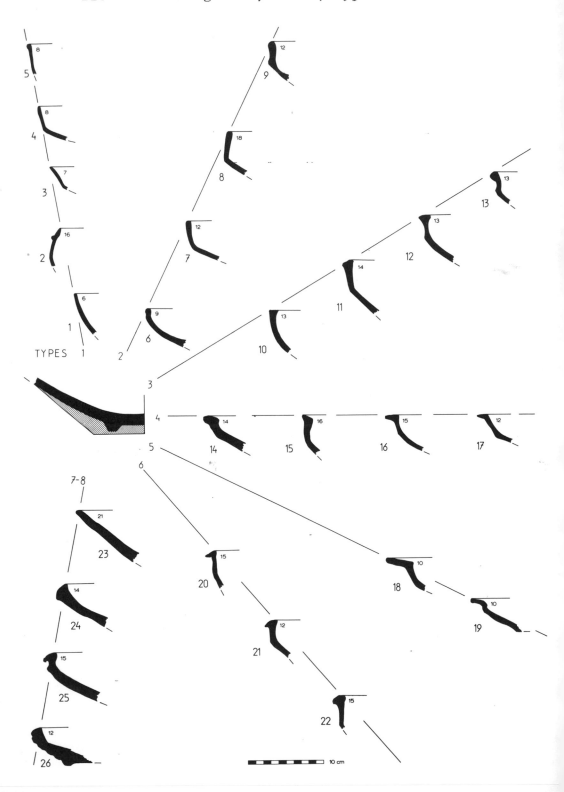

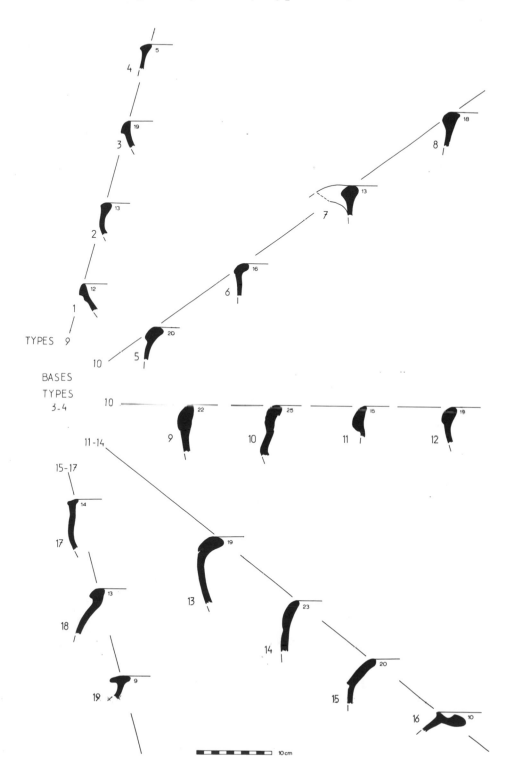

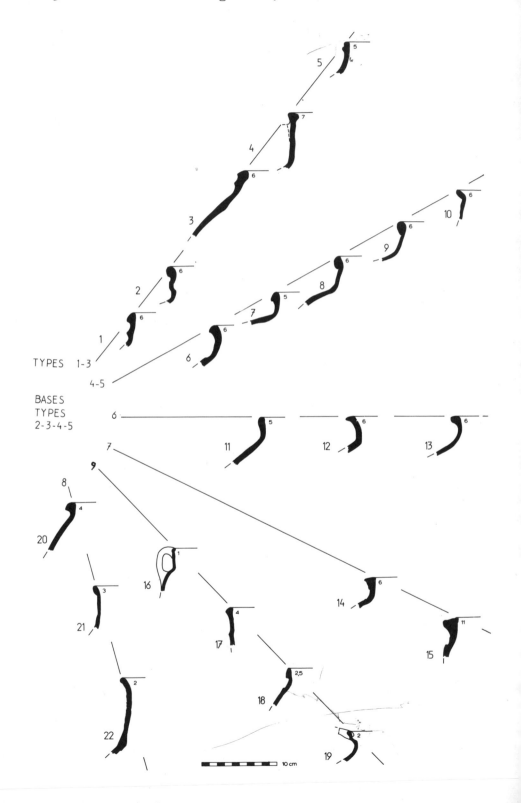

TYPES 1-3

4-5

BASES
TYPES
2-3-4-5

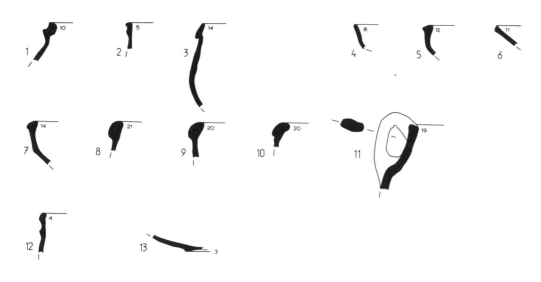

No.		Type	Sherd no.
1	Cooking pot	1a	24/17
2	Cooking pot	1b	24/18
3	Cooking pot	2	24/15
4	Bowl	1	24/5
5	Bowl	3	24/4
6	Bowl	7	24/9
7	Bowl	9a	24/3
8	Bowl	10a	24/1
9	Bowl	10h	24/2
10	Bowl	11	24/30
11	Crater		25/2
12	Jar	1	24/12
13	Base	2	24/24

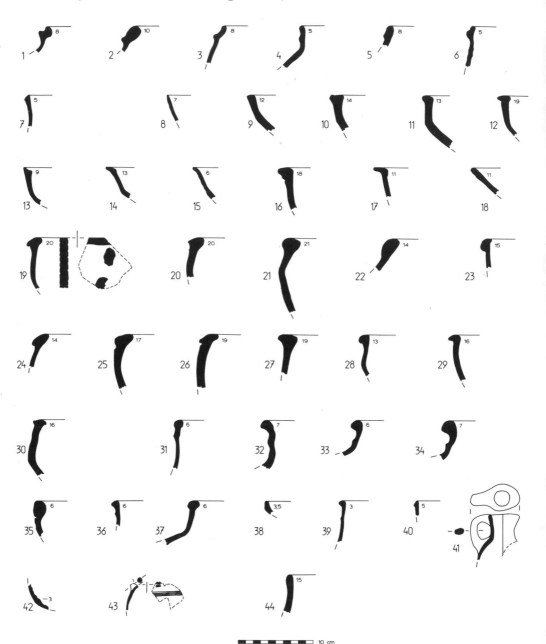

10 cm

Fig.8, Phase 22

No.		Type	Sherd no.
1	Cooking pot	1a	22/83
2	Cooking pot	1a	22/100
3	Cooking pot	1b	22/70
4	Cooking pot	4	22/74
5	Cooking pot	5	22/89
6	Cooking pot	8	22/78
7	Cooking pot	10	22/54
8	Bowl	1	22/31
9	Bowl	3	22/50
10	Bowl	3	22/23
11	Bowl	3	22/1
12	Bowl	4	22/-
13	Bowl	4	22/3
14	Bowl	4	22/44
15	Bowl	5	22/13
16	Bowl	6	22/38
17	Bowl	6	22/48
18	Bowl	7	22/40
19	Bowl	9a	22/19
20	Bowl	10a	22/2
21	Bowl	10d	22/32
22	Bowl	10e	22/-
23	Bowl	10f	22/37
24	Bowl	10h	22/6
25	Bowl	11	22/43
26	Bowl	11	22/21
27	Bowl	16	22/8
28	Bowl	16	22/15
29	Bowl	16	22/22
30	Bowl	16	22/17
31	Jar	1	22/56
32	Jar	1	22/55
33	Jar	1	22/65
34	Jar	1	22/68
35	Jar	2	22/57
36	Jar	3	22/69
37	Jar	4	22/60
38	Jar	8	22/59
39	Jar	9	22/63

Fig.8, Phase 22 (continued)

No.		Type	Sherd no.
40	Jar	9	22/61
41	Jar	9	22/58
42	Base	6	22/89
43	Cypriote jug		22/-
44	High straight neck of large bowl		22/49

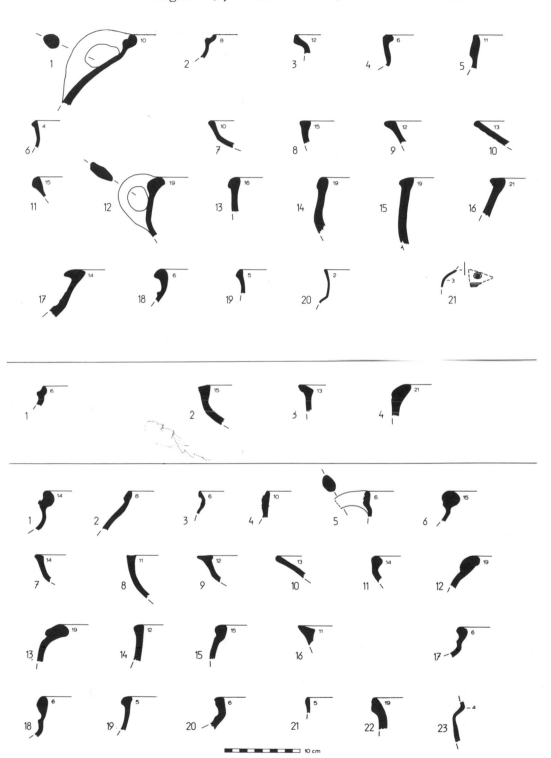

10 cm

Fig.9, Phase 21

No.		Type	Sherd no.
1	Cooking pot	1a	21/6
2	Cooking pot	1b	21/2
3	Cooking pot	3	21/20
4	Cooking pot	4	21/1
5	Cooking pot	5	21/5
6	Cooking pot	10	21/40
7	Bowl	2	21/16
8	Bowl	3	21/12
9	Bowl	4	21/13
10	Bowl	7	21/21
11	Bowl	9a	21/22
12	Bowl	10a	21/41
13	Bowl	10d	21/30
14	Bowl	16	21/29
15	Bowl	16	21/31
16	Bowl	17	21/47
17	Bowl	17	21/28
18	Jar	1	21/32
19	Jar	4	21/35
20	Jar	9	21/48
21	Cypriote juglet		21/42

Fig.9, Phase 20

1	Cooking pot	1b	20/3
2	Bowl	3	20/1
3	Bowl	4	20/2
4	Bowl	11	20/4

Fig.9, Phase 19

1	Cooking pot	1a	19/3
2	Cooking pot	2	19/1
3	Cooking pot	3	19/-
4	Cooking pot	5	19/45
5	Cooking pot	5	19/5
6	Cooking pot	6	19/21

Fig.9, Phase 19 (continued)

No.		Type	Sherd no.
7	Bowl	2	19/19
8	Bowl	3	19/26
9	Bowl	4	19/22
10	Bowl	7	19/25
11	Bowl	8	19/43
12	Bowl	10e	19/14
13	Bowl	11	19/48
14	Bowl	15	19/47
15	Bowl	16	19/17
16	Bowl (divergent shape)		19/18
17	Jar	1	19/28
18	Jar	1	19/42
19	Jar	4	19/41
20	Jar	6	19/29
21	Jar	9	19/20
22	Rim of large bowl		19/51
23	Fragment of juglet		19/57

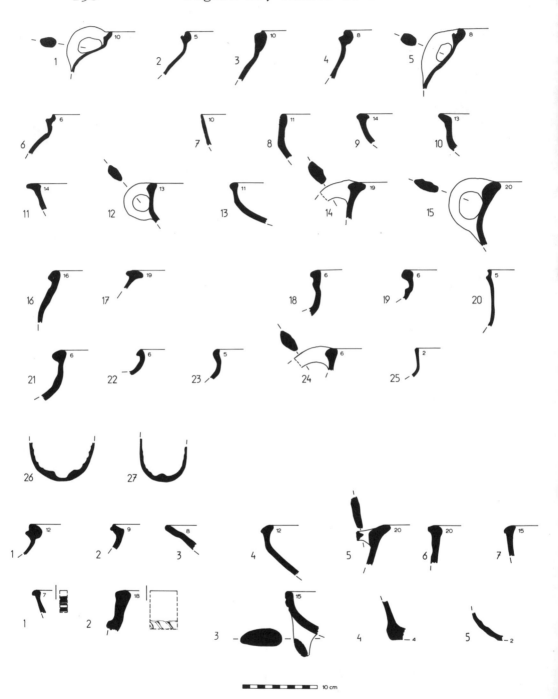

Fig.10, Phase 16

No.		Type	Sherd no.
1	Cooking pot	1a	16/21
2	Cooking pot	1a	16/52
3	Cooking pot	1a	16/59
4	Cooking pot	1a	16/49
5	Cooking pot	1a	16/50
6	Cooking pot	1b	16/42
7	Bowl	1	16/1
8	Bowl	2	16/5
9	Bowl	3	16/13
10	Bowl	4	16/2
11	Bowl	6	16/10
12	Bowl	9a	16/16
13	Bowl	9c	16/4
14	Bowl	10b	16/21
15	Bowl	10e	16/24
16	Bowl	16	16/60
17	Bowl	17	16/14
18	Jar	1	16/31
19	Jar	1	16/35
20	Jar	3	16/26
21	Jar	4	16/32
22	Jar	4	16/65
23	Jar	6	16/29
24	Jar	7	16/36
25	Jar	9	16/57
26	Base	6	16/68
27	Base	6	16/69

Fig.10, Phase 15

1	Cooking pot	1a	15/2
2	Cooking pot	2	15/13
3	Bowl	7	15/16
4	Bowl	9a	15/10
5	Bowl	10e	15/6
6	Bowl	15	15/11
7	Bowl	16	15/12

Fig.10 (continued), Phase 14

No.	Type	Sherd no.
1	Painted jar neck	14/164
2	Rim of large jar	14/71
3	Mortar	14/19
4	Rattle or animal figurine	14/46
5	Base of juglet	14/61

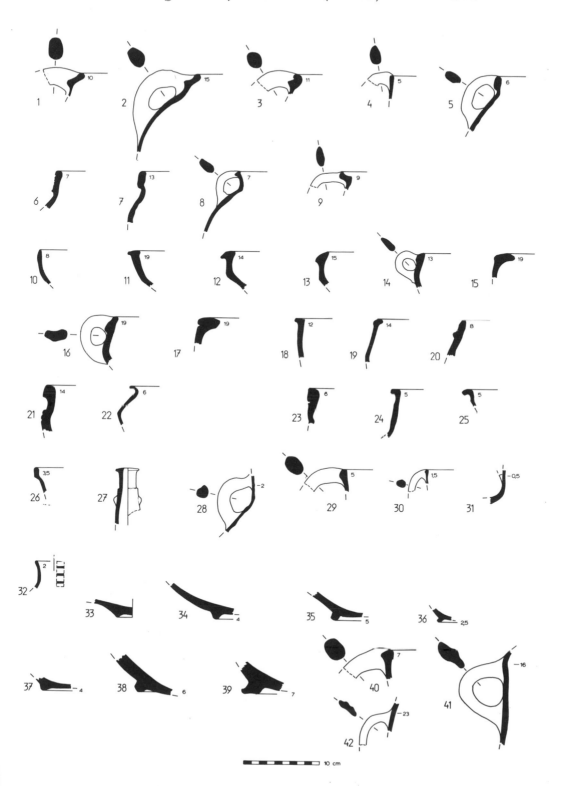

10 cm

Fig.11, Phase 14 (continued)

No.		Type	Sherd no.
1	Cooking pot	1a	14/65
2	Cooking pot	1a	14/15
3	Cooking pot	1a	14/6
4	Cooking pot	4	14/12
5	Cooking pot	5	14/10
6	Cooking pot	5	14/78
7	Cooking pot	5	14/67
8	Cooking pot	11	14/75
9	Cooking pot	12	14/9
10	Bowl	1	14/51
11	Bowl	3	14/81
12	Bowl	6	14/55
13	Bowl	9a	14/72
14	Bowl	9b	14/25
15	Bowl	10b	14/171
16	Bowl	10b	14/21
17	Bowl	11	14/-
18	Bowl	15	14/174
19	Bowl	16	14/77
20	Deep bowl (Iron Age I?)		14/80
21	Crater		14/68
22	Bowl		14/74
23	Jar	2	14/40
24	Jar	5	14/76
25	Jar	8	14/161
26	Jar	8	14/41
27	Jar	9	14/39
28	Jar	9	14/150
29	Jar	9	14/44
30	Jar	9	14/43
31	Jar	9	14/47
32	Jar	9	14/35
33	Base	3	14/165
34	Base	3	14/133
35	Base	3	14/134
36	Base	3	14/127
37	Base	3	14/180
38	Base	4	14/144
39	Heavy base		14/143

Fig.11, Phase 14 (continued)

No.		Type	Sherd no.
40	Handle	1	14/34
41	Handle	2	14/145
42	Handle	3	14/30

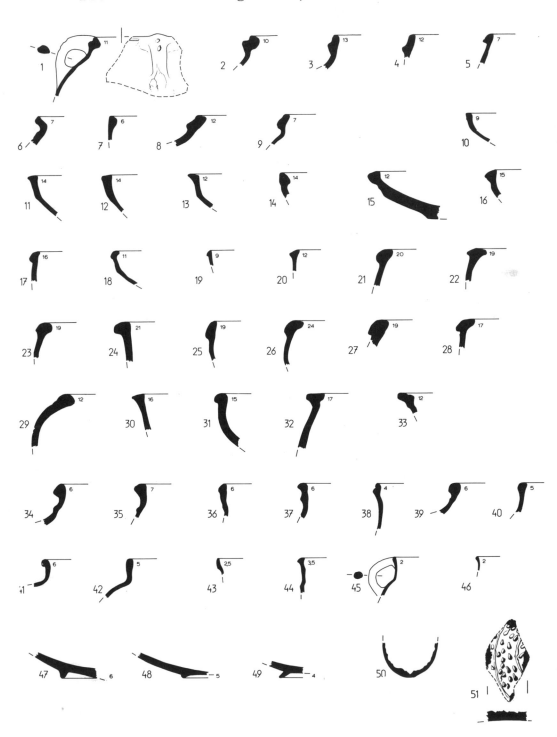

Fig.12, Phase 13

No.		Type	Sherd no.
1	Cooking pot	1a	13/132
2	Cooking pot	1a	13/114
3	Cooking pot	1a	13/135
4	Cooking pot	1a	13/138
5	Cooking pot	2	13/133
6	Cooking pot	3	13/130
7	Cooking pot	4	13/134
8	Cooking pot	5	13/7
9	Cooking pot	5	13/137
10	Bowl	2	13/46
11	Bowl	3	13/38
12	Bowl	3	13/51
13	Bowl	4	13/45
14	Bowl	8	13/48
15	Bowl	8	13/29
16	Bowl	9a	13/66
17	Bowl	9a	13/70
18	Bowl	9a	13/55
19	Bowl	9a	13/78
20	Bowl	9c	13/40
21	Bowl	10a	13/8
22	Bowl	10b	13/5
23	Bowl	10c	13/21
24	Bowl	10d	13/166
25	Bowl	10e	13/17
26	Bowl	10f	13/4
27	Bowl	11	13/2
28	Bowl	11	13/182
29	Bowl	12	13/173
30	Bowl	15	13/28
31	Bowl	16	13/384
32	Bowl	17	13/41
33	Bowl with profiled rim		13/33
34	Jar	1	13/84
35	Jar	1	13/91
36	Jar	1	13/69
37	Jar	1	13/106
38	Jar	3	13/105
39	Jar	4	13/96

Fig.12, Phase 13 (continued)

No.		Type	Sherd no.
40	Jar	4	13/100
41	Jar	4	13/181
42	Jar	6	13/90
43	Jar	9	13/110
44	Jar	9	13/97
45	Jar	9	13/109
46	Jar	9	13/111
47	Base	3	13/149
48	Base	3	13/154
49	Base	3	13/155
50	Base	6	13/144
51	Fragment of baking tray		13/158

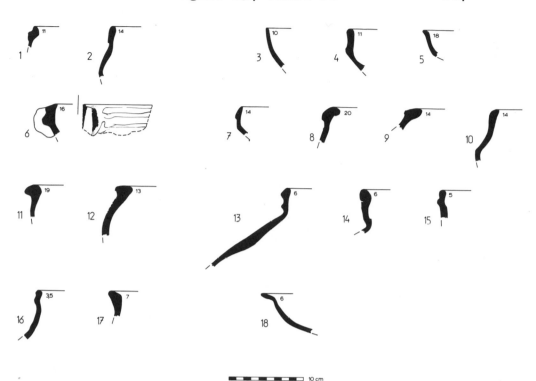

No.		Type	Sherd no.
1	Cooking pot	1a	12/3
2	Cooking pot	5	12/4
3	Bowl	1	12/10
4	Bowl	2	12/16
5	Bowl	2	12/-
6	Bowl	3	12/22
7	Bowl	9b	12/14
8	Bowl	10f	12/19
9	Bowl	11	12/13
10	Bowl	16	12/24
11	Bowl	16	12/15
12	Bowl	17	12/18
13	Jar	1	12/31
14	Jar	2	12/30
15	Jar	3	12/29
16	Jar	3	12/27
17	Jar	4	12/28
18	Base	1b	12/33

Figure 14, Phase 11

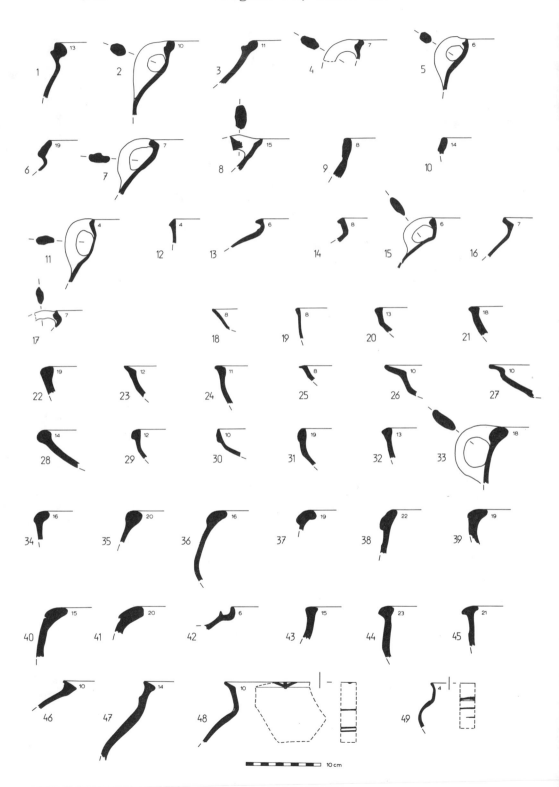

10 cm

Fig.14, Phase 11

No.		Type	Sherd no.
1	Cooking pot	1a	11/38
2	Cooking pot	1a	11/8
3	Cooking pot	1a	11/74
4	Cooking pot	1a	11/47
5	Cooking pot	1b	11/179
6	Cooking pot	2	11/72
7	Cooking pot	3	11/10
8	Cooking pot	5	11/9
9	Cooking pot	5	11/205
10	Cooking pot	5	11/201
11	Cooking pot	10	11/18
12	Cooking pot	10	11/32
13	Cooking pot	11	11/145
14	Cooking pot	11	11/38
15	Cooking pot	11	11/2
16	Cooking pot	12	11/33
17	Cooking pot	12	11/5
18	Bowl	1	11/61
19	Bowl	1	11/63
20	Bowl	2	11/55
21	Bowl	3	11/42
22	Bowl	3	11/46
23	Bowl	4	11/103
24	Bowl	4	11/105
25	Bowl	4	11/193
26	Bowl	5	11/182
27	Bowl	5	11/51
28	Bowl	8	11/61
29	Bowl	9a	11/48
30	Bowl	9b	11/50
31	Bowl	9b	11/24
32	Bowl	9c	11/37
33	Bowl	10a	11/24
34	Bowl	10c	11/77
35	Bowl	10d	11/65
36	Bowl	10e	11/25
37	Bowl	10f	11/55
38	Bowl	10g	11/72
39	Bowl	11	11/86

Fig.14, Phase 11 (continued)

No.		Type	Sherd no.
40	Bowl	11	11/81
41	Bowl	13	11/54
42	Bowl	14	11/141
43	Bowl	15	11/11
44	Bowl	16	11/90
45	Bowl	17	11/34
46	Bowl	17	11/-
47	Crater		11/69
48	Bowl, burnished inside and out on rim - decorated		11/104
49	Bowl, burnished outside		11/216

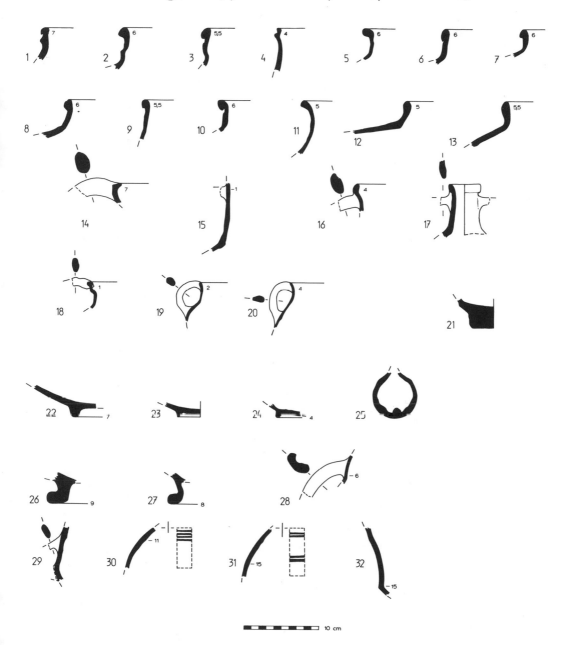

Fig.15, Phase 11 (continued)

No.		Type	Sherd no.
1	Jar	1	11/137
2	Jar	2	11/126
3	Jar	3	11/252
4	Jar	4	11/157
5	Jar	4	11/103
6	Jar	4	11/192
7	Jar	4	11/114
8	Jar	4	11/100
9	Jar	4	11/121
10	Jar	4	11/116
11	Jar	4	11/111
12	Jar	6	11/107
13	Jar	6	11/120
14	Jar	7	11/152
15	Jar	8	11/-
16	Jar	8	11/217
17	Jar	8	11/151
18	Jar	9	11/154
19	Jar	9	11/155
20	Jar	9	11/156
21	Base	1a	11/229
22	Base	3	11/202
23	Base	3	11/237
24	Base	5	11/220
25	Base	6	11/158
26	Base, high ring		11/148
27	Base, high ring		11/78
28	Handle	3	11/181
29	Fragment of small jug		11/210
30	Decorated fragment, body red; black and white bands		11/204
31	Decorated fragment, red burnished body; black horizontal lines		11/219
32	Fragment of jar, horizontally and vertically burnished		11/232

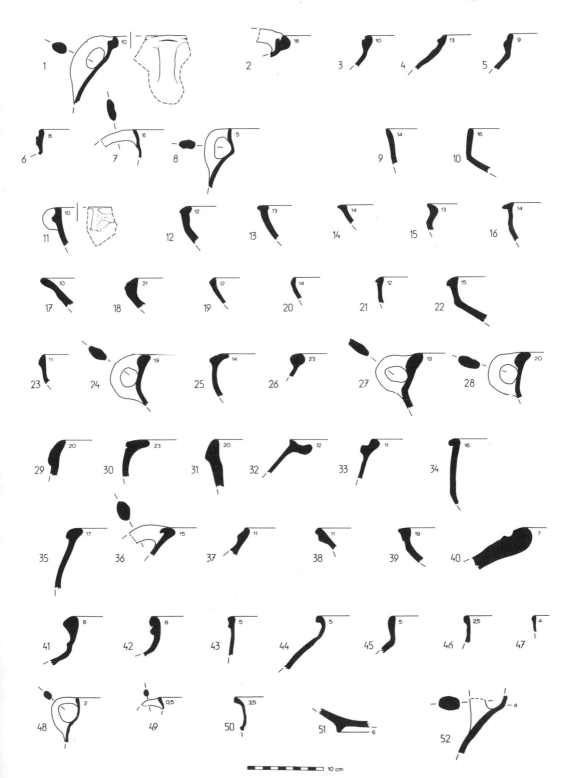

10 cm

Fig.16, Phase 10

No.		Type	Sherd no.
1	Cooking pot	1a	10/1
2	Cooking pot	1a	10/9
3	Cooking pot	1a	10/8
4	Cooking pot	1b	10/23
5	Cooking pot	1b	10/14
6	Cooking pot	5	10/158
7	Cooking pot	9	4/25
8	Cooking pot	10	10/130
9	Bowl	1	10/186
10	Bowl	2	10/207
11	Bowl	2	10/27
12	Bowl	3	10/99
13	Bowl	3	10/108
14	Bowl	4	10/174
15	Bowl	6	10/49
16	Bowl	6	10/209
17	Bowl	7	10/101
18	Bowl	8	10/60
19	Bowl	8	10/6
20	Bowl	8	10/208
21	Bowl	9a	10/112
22	Bowl	9a	10/53
23	Bowl	9b	10/196
24	Bowl	10a	10/80
25	Bowl	10b	10/89
26	Bowl	10c	10/98
27	Bowl	10e	10/50
28	Bowl	10f	10/206
29	Bowl	10g	10/22
30	Bowl	11	10/90
31	Bowl	13	10/58
32	Bowl	14	10/88
33	Bowl	14	10/30
34	Bowl	16	10/29
35	Bowl	16	10/87
36	Bowl	17	10/55
37	Deep bowl		10/25
38	Bowl with profiled rim		10/18
39	Bowl with profiled rim		10/100

Fig.16, Phase 10 (continued)

No.	Type		Sherd no.
40	Heavy hole-mouth jar		10/83
41	Jar	1	10/31
42	Jar	2	10/125
43	Jar	3	10/20
44	Jar	4	10/47
45	Jar	6	10/200
46	Jar	8	10/44
47	Jar	9	10/61
48	Jar	9	10/111
49	Jar	9	10/-
50	Jar	9	10/41
51	Base	3	10/147
52	Handle	1	10/122

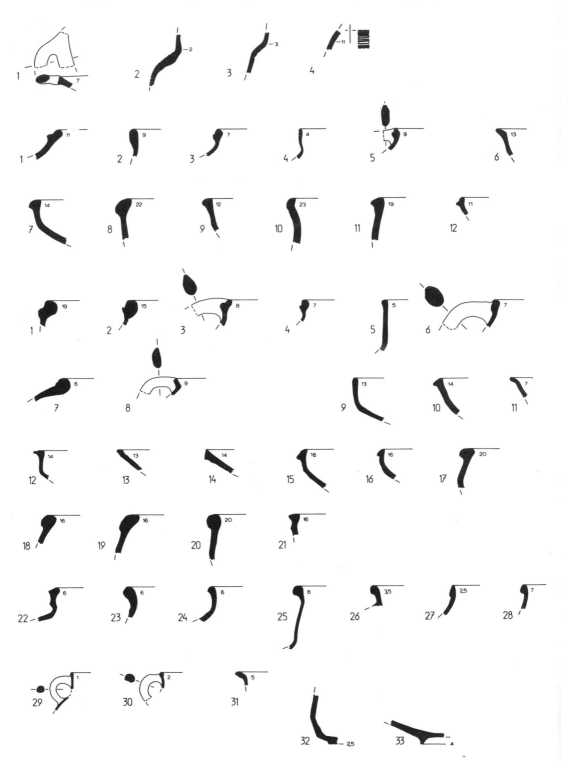

10 cm

Fig.17, Phase 10 (continued)

No.	Type		Sherd no.
1	Fragment of bowl handle		10/175
2	Fragment of jug		10/172
3	Fragment of juglet		10/179
4	Decorated fragment, black and white lines on red body		10/128

Fig.17, Phase 8

1	Cooking pot	1b	8/24
2	Cooking pot	5	8/22
3	Cooking pot	5	8/34
4	Cooking pot	10	8/35
5	Cooking pot	12	8/23
6	Bowl	4	8/1
7	Bowl	9	8/3
8	Bowl	10h	8/4
9	Bowl	15	8/12
10	Bowl	16	8/19
11	Bowl	16	8/29
12	Bowl with profiled rim		8/5

Fig.17, Phase 7

1	Cooking pot	1a	7/76
2	Cooking pot	1a	7/5
3	Cooking pot	1a	7/6
4	Cooking pot	1a	7/4
5	Cooking pot	4	7/222
6	Cooking pot	5	7/-
7	Cooking pot	6	7/17
8	Cooking pot	12	7/19
9	Bowl	2	7/38
10	Bowl	3	7/4
11	Bowl	5	7/64,190
12	Bowl	6	7/56
13	Bowl	7	7/269
14	Bowl	7	7/62

Fig.17, Phase 7 (continued)

No.		Type	Sherd no.
15	Bowl	9a	7/255
16	Bowl	9b	7/262
17	Bowl	10a	7/184
18	Bowl	10d	7/24
19	Bowl	10e	7/22
20	Bowl	16	7/52
21	Bowl with profiled rim, burnished outside		11/267
22	Jar	1	7/166
23	Jar	1	7/168
24	Jar	4	7/162
25	Jar	5	7/169
26	Jar	8	7/180
27	Jar	8	7/215
28	Jar	9	7/185
29	Jar	9	7/211
30	Jar	9	7/172
31	Jar	9	7/186
32	Base	2	7/165
33	Base	3	7/176

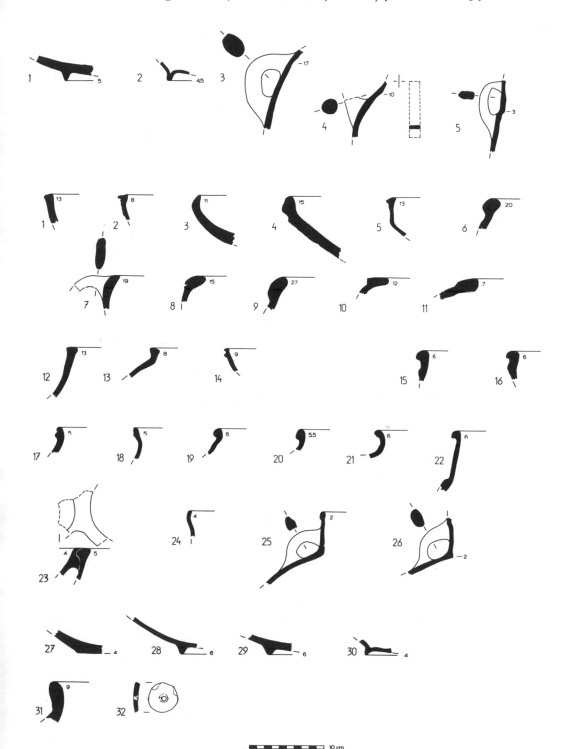

Fig.18, Phase 7 (continued)

No.		Type	Sherd no.
1	Base	3	7/193
2	Base	5	7/-
3	Handle	1	7/171
4	Handle	2	7/175
5	Handle	3	7/206

Fig.18, Phase 6

1	Bowl	2	6/263
2	Bowl	6	6/86
3	Bowl	8	6/-
4	Bowl	8	6/-
5	Bowl	9a	6/-
6	Bowl	10c	6/4
7	Bowl	10e	6/10
8	Bowl	11	6/10
9	Bowl	12	6/24
10	Bowl	13	6/27
11	Bowl	13	6/-
12	Bowl	15	6/-
13	Bowl	17	6/-
14	Bowl with profiled rim		6/-
15	Jar	1	6/1
16	Jar	1	6/101
17	Jar	3	6/102
18	Jar	4	6/103
19	Jar	4	6/104
20	Jar	4	6/105
21	Jar	4	6/106
22	Jar	5	6/26
23	Jar	7	6/107
24	Jar	8	6/108
25	Jar	8	6/109
26	Jar	8	6/110
27	Base	2	6/111
28	Base	3	6/112
29	Base	3	6/113
30	Base	4	6/114

Fig.18, Phase 6 (continued)

No.	Type	Sherd no.
31	Rim of heavy jar	6/115
32	Spindle whorl	6/116

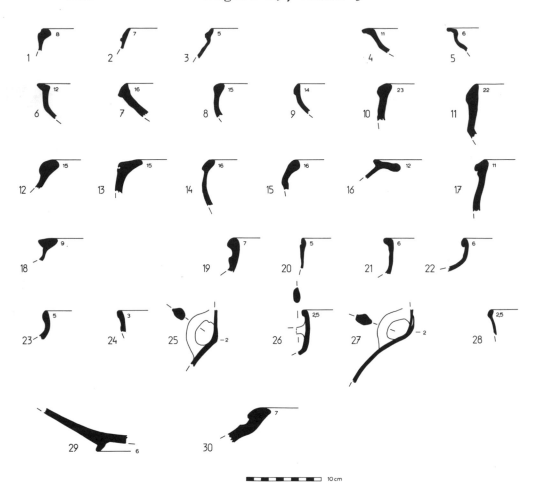

Fig.19, Phase 5

No.		Type	Sherd no.
1	Cooking pot	1a	5/1
2	Cooking pot	5	5/-
3	Cooking pot	7	5/74
4	Bowl	4	5/266
5	Bowl	5	5/43
6	Bowl	6	5/29
7	Bowl	8	5/27
8	Bowl	9a	5/33
9	Bowl	9b	5/42
10	Bowl	10a	5/74
11	Bowl	10e	5/22
12	Bowl	10f	5/97
13	Bowl	11	5/75
14	Bowl	11	5/40
15	Bowl	12	5/26
16	Bowl	14	5/60
17	Bowl	16	5/28
18	Bowl	17	5/62
19	Jar	2	5/59
20	Jar	3	5/20
21	Jar	4	5/50
22	Jar	4	5/52
23	Jar	6	5/55
24	Jar	8	5/58
25	Jar	8	5/64
26	Jar	8	5/65
27	Jar	8	5/68
28	Jar	9	5/49
29	Base	3	5/70
30	Rim of heavy jar		5/21

Figure 20

Construction drawing of the Iron Age I cooking pot.

Figure 20 165

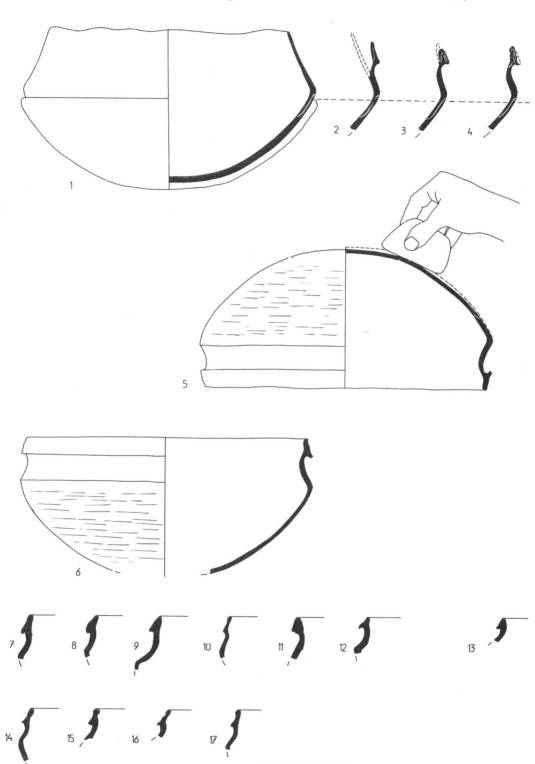

Figure 21

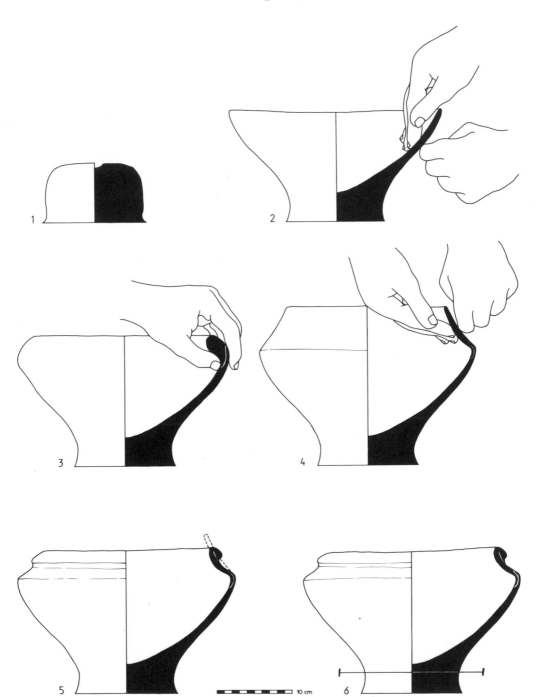

10 cm

Figure 22 167

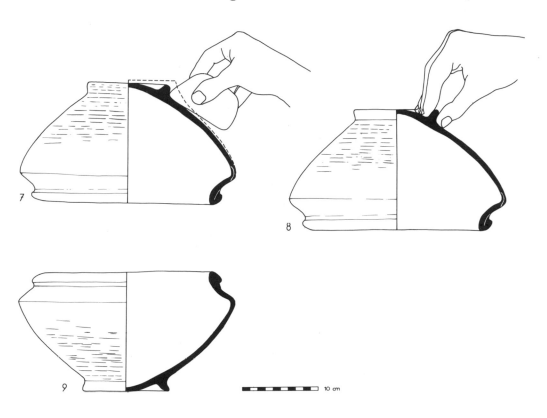

Figures 21,22

Construction drawings of the Iron Age I large
bowl.

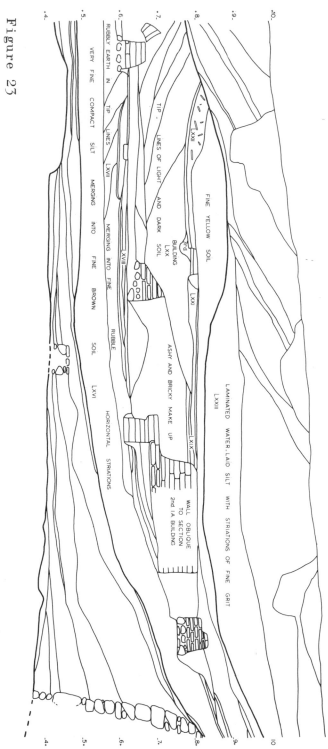

Figure 23

The Iron Age deposits in vertical section; Trench I, North side.

Aharoni, Y., 1962. Excavations at Ramat Raḥal;
 Rome

Crowfoot, J.W., Crowfoot, G.M. & Kenyon, K.M.,
 1957. The Objects from Samaria; London

Franken, Henk J., 1968. London Illustrated News,
 July 20, p.30, Fig.3

Franken, Henk J. & Kalsbeek, J., 1969. Excavations
 at Tell Deir ᶜAllā, I, (1), Ch.IX; (2),
 p.243f; (3), Fig.42; (4), p.128; (5),
 pp.162-164; Leiden

Franken, Henk J., 1971. Analysis of Methods of
 Potmaking in Archaeology, pp.227-255.
 Harvard Theological Review 64

Franken, Henk J., 1973. In 'Symbolae Biblicae et
 Mesopotamicae Francisco Mario Theodoro
 De Liagre Böhl', pp.144-148. Ed. M.A.
 Beek c.s.; Leiden

Franken, Henk J., 1974. Excavations at Tell Deir
 ᶜAllā - The Medieval Tell and Cemetery:
 Tell Abu Gourdan, (1), Ch.X; (2), Section
 114. Ed. Department of Antiquities;
 Amman

Kelso, J.L. & Palin Thorley, J., 1943. Tell Beit
 Mirsim, Vol.III, Ch.IV; AASOR Vols.
 XXI-XXII

Kenyon, K.M., 1942. In J.W. Crowfoot, K.M. Kenyon
 & E.L. Sukenik, The Buildings at Samaria,
 p.93ff; London

Kenyon, K.M., 1952. Excavations at Jericho, p.71.
 Palestine Exploration Quarterly

Kenyon, K.M., 1957. Digging up Jericho, p.263f.;
 London

Lapp, Paul W., 1968. Beth Zur, p.38. AASOR
 Vol.XXXVIII

Mazar, B., Dothan, T. & Dunayevski, I., 1966.
 En-Gedi. ᶜAtiqot, English Series Vol.V;
 Jerusalem

Munsell, 1954. Munsell Soil Color Charts;
 Baltimore

Picard, L.Y. & Golani, U., 1965. Israel Geologic-
 al Map, Northern Sheet

Tushingham, A.D., 1965. Tombs of the Early Iron
 Age, p.479ff., in Kenyon, Excavations at
 Jericho Vol.2, B.S.A.J.; London

Tufnell, O., 1953. Lachish, Vol.III; London

Yadin, Y., Aharoni, Y., Amiran, R., Dothan, T.,
 Dunayevski, I. & Perrot, J., 1958.
 Hazor, Vol.I; Jerusalem

Yadin, Y., 1960. Hazor, Vol.II; Jerusalem

Part Two

METHODS OF POTMAKING

IN NEOLITHIC TIMES

AT JERICHO

With Contributions By
J. Kalsbeek

INTRODUCTION

The following report on Neolithic pottery from Jericho is a revised version of a preliminary report made at the request of Dr. K.M. Kenyon.

The material that was presented for study consisted of all the stratified Neolithic pottery fragments from Trench II, mainly found in pits. In the present study two other small groups of Neolithic pottery have been taken into consideration. One is the pottery found in the so-called Hyksos Bank in the same trench, the other is pottery that was discarded by the excavator after inspection on the pottery mats, and now in the sherd collection in Leiden. This group has to be considered as unstratified. It comes from Neolithic levels dug during the seasons 1955 and 1956.

The preliminary report consisted of two parts. The material was studied by the ceramic expert, Mr. Jan Kalsbeek, who worked with the results of a few analyses of thin-slides. These thin-slides and the ones that were added later on were all taken from the Leiden collection. Some of his conclusions as far as they were based on the analysis of the clays used by the Neolithic potters, had to be revised. This concerned only the question of the silty and non-silty clays. The revision did not fundamentally change his analysis.

The second part was written in an attempt to give an interpretation of the results of this analysis in relation to the most important question: does the Pottery Neolithic B group as defined by Dr. Kenyon have links with the Pottery Neolithic A group? She has worked for many years with her typology which is based on carefully chosen type-sherds. She has also made correlations between our division of the pottery and her own types. As will be seen, our division is not based on the appearances of wares but on general characteristics of the possibilities of shaping the

pastes. The second difference is that we have not
based our research in this report on the strati-
graphical evidence, since this evidence can be
used as an independent control system on the tech-
nological study. What is considered 'later' from
a technological point of view need by no means be
later in the stratigraphical sequence. 'Earlier'
or 'later' in this report are not to be translated
in terms of the stratigraphical sequence. There
are mainly two aspects that have to be considered.
The first one is the stratigraphical situation.
The pottery comes from many pits. Each time a pit
is dug, pottery that is buried there comes to the
surface. If, as is often the case at Jericho, a
later pit cuts through the deposit of excavated
earth from an earlier pit, this earth and the
sherds it contains is moved up again. The other
aspect is that no matter how convincing a techno-
logical development, constructed from the study of
the fragments, may be, two stages of development
may have existed side by side. If this pottery
was produced by several groups or families, one
such group may have stuck to a time-honored method
whereas the other groups advanced by improving
their products. Or to mention another possibility,
part of the pottery was locally made but this was
supplemented by the purchase of pottery from trav-
eling potters. A few thin-slides indicate that
pottery already migrated in those early times.
Thus although generally this pottery seems to be-
long to one stream of tradition the stage of de-
velopment may have been different in contemporane-
ous groups. Therefore in this study it is not the
task of the analyst of the pottery technology to
apply his results to the stratigraphical evidence.
The archaeological evaluation of this study has to
be worked out by the archaeologist in relation to
all other evidence, the artefact study, the build-
ing remains, etc.
 If it turns out that some Neolithic B pottery
is already found in a Neolithic A context, this by
itself is not in contradiction with the thesis as

published already in Kenyon, 1957, that the Neo-
lithic B group superseded the A group. What is
important from the technological angle is the
question whether the Neolithic B group is a branch
of the same tradition to which the Neolithic A
group belongs, or whether B represents an inde-
pendent tradition.

In this report sections 1-7 are from the hand
of J. Kalsbeek, the ceramic expert who is attached
to the Institute of Palestinian Archaeology of the
Leiden University.

Dr. K.M. Kenyon will publish in due course the
Neolithic pottery from all the sites excavated at
Jericho.

1. GENERAL REMARKS

A reliable method for distinguishing kinds of
ceramics is one which is based on an examination
of the differing compositions of the raw materi-
als. It is only when these compositions show no
distinguishable differences that the investigation
should begin with a technical analysis of the
manufacture of the product. Only in the latter
instance should the different shapes of ceramics
be studied. For certainly the shape is for the
most part dependent upon the composition of the
raw materials and on the technique which was ap-
plied. If only the resultant shape is appraised
without a thorough study of the composition of the
material and the method by which the pot was manu-
factured, it is impossible to arrive at an accu-
rate understanding of the connection - or lack of
connection - which can exist between the consecu-
tive phases.

The subject of this report is the Neolithic
group of pottery from Jericho. The difference of
material composition within this group warrants an
investigation first of all of this aspect. Be-
cause the choice of the composition of raw materi-
als completely hinges on the technique which is
applied, it is important to treat these two as-
pects collectively. The following is an attempt
to place these different developments 'in their
chronological order.

Changes in composition, technique and form re-
quire time; and it is theoretically possible to
classify these processes into earlier and later
and contemporaneous periods. But in practice, it
is difficult to determine whether evolution or
regression occurred, or whether objects are con-
temporaneous, without the substantation of accu-
rate stratigraphy. And while accurate stratigra-
phy is also theoretically possible, it too is only
feasable as long as layers follow consecutively
and there exist sharply defined lines of demarca-
tion. When formidable disturbances occur, such as

pits and holes (often discovered only after the
pottery has been removed and mixed), accurate
stratigraphy is practically impossible.

Therefore if the excavated material is viewed
from these two different aspects - the strati-
graphical development and the development of the
pottery - it is then possible to correct both.
With this combination we can conduct a much more
solidly grounded investigation.

Each fragment is important to the study of
technique, regardless of the part of the pot it
represents. Even marks left inadvertently can be
translated into the characteristics of an applied
technique.

The Jericho pottery collection consists largely
of rim and handle fragments. Wall and base frag-
ments are present only in small quantities. Thus
it must be concluded that not all the excavated
sherds are in this collection. And consequently,
the scope of information about the employed tech-
niques has been drastically narrowed. Transitions
between different techniques are clearly ascer-
tainable. However, because of this limitation it
is often possible to illustrate these transitions
with only a single fragment.

2. THE BASIC COMPOSITION OF THE RAW MATERIAL

1. Clay + inorganic material
2. Clay + organic material
3. Clay + organic + inorganic material.
 The basic technique:
1. Completely hand-made on a stationary base
2. Hand-made and finished on a turning base.
 If sherds are examined on the basis of the pre-
 ceding aspects, the following can be concluded:
 Clay tempered with inorganic material was used
both for working on a stationary and a turning
base. Clay tempered with organic material was ex-
clusively worked on a stationary base. As it is
presupposed that forming on a turning base is a

technical development which follows hand-making on
a stationary base, it must be concluded that these
techniques either followed each other or were si-
multaneous. If the hand-made pottery follows the
pottery finished on a turning base, we must assume
a cultural break between the two forms of pottery.

A closer specification of the clay mixed with
inorganic material:
1. Clay tempered with small fragments of flint,
 lime, calcite or shell fragments
2. Clay tempered with crushed pottery (grog)
3. Clay tempered with the same material as 1, but
 this added after sifting.

A closer specification of the clay mixed with
organic material:
1. Clay tempered with straw or grass
2. Clay tempered with fine pieces of chaff.

A closer specification of the clay mixed with
material from both organic and inorganic origin:
1. Clay tempered with small fragments of flint,
 lime, calcite and chaff with occasionally
 coarse straw
2. Clay tempered with pottery grits and fine
 pieces of chaff.

3. CLAY WITH INORGANIC MATERIAL, Group 1

(Clay tempered with fragments of flint, lime,
calcite or shell.)
1. The fragments are of radically different sizes.
 Therefore they could not have been sifted
2. The fragments are rounded. We must conclude
 that they have been thus formed by nature.
 Therefore crushing the different stones to
 achieve this effect can be excluded
3. The salt layer (scum or bloom) on the outside
 of the pots made from this polluted clay can be
 attributed to the large salt content of the

clay caused by a drying out of the river bed.

The technique of working this clay into a pot is completely interrelated to these kinds of clay. The technique is as follows:

A flat, round, kneaded piece of clay was attached to a flat base. The wall was then built up from pressed, flat clay strips. With the aid of a flint scraper the walls were made more uniform and the desired shape achieved. A wide variation of shapes was not possible because the coarse composition of the clay made a kneading out of the wall into a spherical shape impossible without tearing. Hand-molding the wall was also difficult because the clay impurities are fragments with sharp edges which easily injure moist hands. That is why a piece of leather was used to smooth the exterior of the pot.

The pots have been scraped with a scraper, and not with a tuft of straw, as evidenced by the impressions left on the pot. The narrow breadth of the streaks are not those of straw; it might suggest a small brush. However the form and appearance of the indentions do not indicate a pliable tool. The surface was more certainly scraped than brushed. The direction of the streaks bears this out. They run crossways over those parts of the pot which were further treated, e.g. to make a wall thinner at a point where it had remained too thick.

Small pots were sometimes also touched up on the inside - pots too narrow in circumference to have contained a tuft of straw.

The Shape

The pots in this group have thick walls and flat bases without mat impressions. The base and wall form a sharp angle which has not been rounded off. The profile of the wall is straight, either completely vertical or diagonal. The rims are generally unprofiled, though some have been flattened. This group contains no small shapes.

Handles

The handles are attached very well to the pots. This strong adhesion is evidenced by the fact that pieces of walls have always broken off with the handles. The phenomenon of handles is positive indication of a long pottery tradition. However, in the later stage of this technique the material of the handles was no longer suitable for this purpose.

Firing

The material has been remarkably well fired. This is evident from the absence of dark cores and the lack of discolorations on the outer surface. It is inconceivable that the pots were fired in an open fire. Rather, we must assume a kiln, or speak in terms of an enclosed space where the fire was well regulated.

4. CLAY TEMPERED WITH ORGANIC MATERIAL, Group 2

This type of clay is completely free of coarse particles. It contains no small stones or similar fragments. This lack of impurity is characteristic of clays found fairly pure in nature, i.e., in sedimentary clay deposits. Because of its extreme plasticity, the clay must be tempered in order to reduce the large amount of shrinkage during drying. Thus the organic material in the clay should be viewed as an added ingredient to counteract heavy shrinkage. The organic temper burns away during firing, leaving holes in the wall of the vessel. The fuel is in the sherd, which indeed facilitates firing. However the resultant porous wall weakens the pot. An overlaying slip was often used to compensate for this weakness. It was applied before firing and usually colored with a pigment. To facilitate adhesion to the surface as much as possible, the slip was burnished after application - a step which greatly enhanced the exterior appearance of the pot.

However the sheen can disappear already if the
vessel is fired higher than 750°C.

The organic temper can be classified into two
groups: a straw and a fine chaff. Generally the
coarse material was used in larger pots, although
a few smaller types also contain it. By contrast
the fine chaff is found in small models. Due to
the lack of large quantities of inorganic material
the sherd is extremely hygroscopic. Consequently
the slip can be applied thickly to the wall.

The method of construction is similar to that
of the previous group. The wall was built up by
stacking flat strips of clay on top of each other.
But with this clay it was easier to fasten the
strips together because it contains no small,
sharp stones. Though a scraper was certainly
used, the traces have been almost wiped away by
the wet finishing of the pot with a piece of
leather. The bases of larger shapes are flat, and
the angles formed by the bases and the walls have
been rounded off. These pots were probably made
on an old base fragment of a broken pot. The
smaller models also have rounded bases. However
the center of these bases have occasionally been
pushed in, producing a concave effect. These
rounded bases are probably the result of a shaping
dish used during the pot making process.

The composition of the clay in this group makes
more shapes possible. For instance, more spheri-
cal shapes could be produced. From the available
evidence we can be certain that the potters used
this quality of the clay to full advantage.

Handles

Present, though in smaller quantities than in
the previous group. In contrast to the previous
group, the handles of the larger pots have broken
off the walls. The adhesion does not appear to
have been strong enough. This is perhaps the re-
sult of heavy shrinkage during drying, especially
problematic for those parts which are added to the
pot later. An uneven process occurs, the result

of two factors: differing degrees of moisture in
the two parts and the differences of surface area
in proportion to volume. Uneven drying and shrink-
age cause another problem. Because the outer sur-
face dries before the inner surface, thicker bases
crack through the middle between the inner and out-
er surfaces.

The firing process is comparable to that of the
previously described pottery group. These pots
have been evenly fired as evidenced by the uniform
color throughout the sherd, with no dark core.

On the basis of the two temper groups there is
no conclusive evidence to decide which one is the
earliest. From the thin-slide analysis it has be-
come clear that the coarse sand was not found with
the clay but added on purpose. Therefore two dif-
ferent groups are found at the earliest stage
which both show that some development had already
taken place. Especially in the second group the
extremely difficult task of mixing has been very
thoroughly performed, as evidenced by the even
distribution of the organic material throughout
the clay.

5. CLAY TEMPERED WITH MATERIAL FROM BOTH ORGANIC AND INORGANIC ORIGIN, Group 3

The material strongly indicates that this group
of pottery should be viewed as a mixture of the
tempering material in Groups 1 and 2: flint, lime,
sand, calcite, coarse straw, grass, or fine chaff.
The coarse inorganic fragments occur in less quan-
tity and are more sparsely concentrated. The or-
ganic temper in this clay mixture serves to neu-
tralize the heavy shrinkage.

The mixing of the clays has long been a practice
of potters to utilize the very best properties of
two or more different kinds of clay. It is one of
the most effective methods and is still practiced
today in ceramic factories. Mixing could account
for the uneven composition in this group, the

result of poor blending of inorganic material and
varying concentrations of these fragments in the
sherds. This situation is indicative of the labo-
rious task of mixing two different clays.

The method of pot building is the same as in
Groups 1 and 2.

6. CLAY TEMPERED WITH GROG AND FINE FRAGMENTS OF CHAFF, Group 4

The use of grog in the clay composition leads
us to conclude that this tempering material has
undoubtedly been added to the clay for a specific
purpose. Moreover it is produced by crushing
larger pottery fragments. This small grog cannot
easily be mixed through the clay. Therefore a
frequent occurrence of ceramic products with this
kind of temper indicates a possible pottery indus-
try. This would explain the source of the large
quantities of grog. A primitive firing process
usually produces sufficient losses to satisfy the
question of the origin of grog.

In this group pottery grog has been added to
the clay now and then in large quantities to coun-
ter shrinkage. The use of such quantities indi-
cates that the original clay must have been very
pure. There is also much variation in the grog
itself. For not only does it vary in amount but
also in size. In some cases a portion of organic
material has been added to this mixture. This,
however, is relative - the more grog the less the
amount of organic temper needed to decrease heavy
shrinkage. Likewise the less grog, the more
organic.

The technique differs only slightly in compari-
son to the previous groups. The walls have been
constructed with flat strips of clay either upon a
flat surface or in a shaping dish, producing a
round base. The limitations imposed by the mate-
rial composition are not too severe; thus more
rounded shapes could be produced. As far as can

be determined from this small collection, the pots
were not finished with a turning movement, though
the possibility exists with the use of a shaping
dish. Often the pots were painted, in some cases
they were decorated with a pattern; others were
completely coated. From the material it appears
that when grog was added to the clay in large
quantities, the pots were difficult to paint, be-
cause the larger quantities of grog greatly re-
duced the porosity of the pot wall. As a result
it was difficult to apply the paint thickly
enough. The application of the paint became even
more difficult because the composition of the raw
materials could be worked into thinner walls. To
compensate for these difficulties and to give the
pattern sharper definition, the potters circled it
with engraved lines. Because the grog temper lay
on the surface, burnishing the background was also
more difficult. Consequently, the pots were bur-
nished only superficially or not at all.

Handles
 The striking fact of this group of pottery is
the sporadic occurrence of handles. Only on the
very small pots are they found frequently. The
larger pots have knobs and small lugs instead of
loop handles. Occasionally the small knobs have
been bored through, giving a sort of 'mouse ear'
effect. The large amount of shrinkage in the clay
is probably the reason for attaching these small
protrusive grips.
 This last group shows the following develop-
mental possibilities: an increasing refinement of
both tempering material and the painting of the
patterns. A decline can also be observed; bur-
nishing is occasionally omitted. And under the
influence of the changed composition of the back-
ground, the pattern is encircled with engraved
lines.

7. CLAY TEMPERED WITH LARGE QUANTITIES OF SIFTED INORGANIC MATERIALS, Group 5

The fineness of this tempering material indicates that it was sifted before being added to the clay. The large quantity used indicated the use of a very plastic clay – again probably the silted clay. Because this kind of clay can be easily worked, few technical difficulties result.

Technique

The most outstanding phenomenon of this group is the making of the pot on a turning base. The method of construction is as follows:

A flat base was made on a small flat mat, and then the wall was constructed of flat strips of clay. However the unique feature is that before a new strip was attached, each part of the wall was first finished, made thinner, and shaped in a complete turning movement. In this manner rather large, spherical-shaped parts could be occasionally attached around the top opening, resulting in a jar-shaped pot. This collar was also finished with a complete turning movement of one hand, while the other kept the base revolving – causing the original upright collar to flare outward or bend inward. Small plates and trays were also constructed in this manner. Thus they, too, are more spherical than those made completely by hand.

The pottery was painted. But because the absorbative power of the dry walls was drastically reduced due to the large quantities of inorganic material used, the paint adhered very poorly. Consequently it had a tendency to drip off during application. These pots are not burnished. Because of the mechanical nature of manufacturing, the free pattern of painting is replaced by a pattern of lines which run in the turning direction over the wall of the pot. Sometimes the entire outer surface is coated with paint and then decorated with engraved lines.

Handles
 Present. The clay composition facilitates the
attachment of handles. This is primarily the re-
sult of the tempering material which sufficiently
absorbs the difference in shrinkage encountered
when a part is attached in a later stage of con-
struction. The fact that the handle always tore
off a piece of the wall when a pot broke is visi-
ble evidence of the strong adhesion.

Firing
 These pots have been fairly well fired, as evi-
denced by the infrequent occurrence of a dark
core. The lime grits did, however, offer diffi-
culties. They began to disintegrate above 600°.
But since this was a rather slow process, it could
be prevented as much as possible by reaching the
highest temperature possible in the shortest peri-
od of time. From a technical standpoint this
group of pottery is the most developed. Because
decoration was largely adapted to technical inge-
nuity, much of the animation and beauty was lost.
Yet on the other hand, a good product was manu-
factured, and it was possible to produce it in
rather large quantities.

8. THIN-SLIDE ANALYSIS

 From sherds in the collection of Leiden 92
slides were made. These sherds are surface finds,
or collected from the pottery fragments that were
not kept when the selection was made on the pot-
tery mats.
 Dr. J. Glass, a geologist in Leiden, made a
preliminary survey of some thin-slides. From his
study it became clear that the distinction between
silted clays and non-silty clays could not be made
without the aid of a microscope. The coarse non-
plastic impurities must have been added by the
potters. It follows that the non-silty clay is
not purified clay. The distinction made by

Dr. Glass is as follows:
1. Silty clay containing large proportions of fine non-plastic grains: mainly quartz and few grains of plagioclase, biotite, muscovite in addition to fine carbonite and microfossils;
2. Non-silty clay containing only carbonite and microfossils as fine non-plastics and no quartz and other minerals or only a few grains of these;
3. Dolomitic clay, containing fine rhombohedral dolomite crystals.

Recently some clays found in the neighborhood of tell es-Sultan were sent to Leiden by Dr. John Landgraf. Clay no.1 comes from the pottery work-shop that existed for a short time north of the cAin es-Sultan refugee village. Work stopped there at the time of the June War 1967. The site is situated at the crossing of the road to Beisan and the Wadi Nuceima, Map ref. 1932/1433. On the Geological Map of Israel the area is marked S3= Campanian (Upper Cretaceous). (Picard & Golani, 1965.)
Clay no.2 comes from the area between the Wadi Qelt and Aqaba Jaber refugee village, Map ref. 1915/1393, the area marked q = Quaternary.
Clay no.3 comes from the side of the Wadi Nuceima where the road to Khirbet Mefjer crosses the wadi, Map ref. 1935/1429. The area is marked Quaternary.
Clay no.4 is from a 'hogback' brick used to build the round houses during the Pre-pottery Neolithic A period, found in Trench II at tell es-Sultan.

Clay no.1 is a red-firing clay. When fired at 600^o it becomes 2.5YR 6/6, light red. It contains quartz, fine grit size, some chalk grains and sandstone, but no microfossils. It is likely that the potter took his clay from the same findspot as did the Kerami potter, which is roughly at the height of sealevel on the Arda Road from the Valley to es-Salt. When dry, the clay is 2.5Y 7/6, yel-low. It is a fairly plastic clay that can be used for throwing.

Clay no.2 is a carbonaceous clay, full of micro-

fossils. There is a considerable amount of quartz
in the sizes very fine to extremely fine. When
fired at 600° the color is 10YR 7/4, very pale
brown; the unfired clay is 2.5Y 7/2, light grey.
The color of the fired clay comes very near to one
of the three colors found in our test of colors at
850°C.

Clay no.3 also contains very fine quartz but
less than clay no.2 and many more microfossils,
which are much larger than those of clay no.2. It
has some coarse chert and medium calcite grains
and fine dolomite crystals. It certainly is a
very carbonaceous clay. Unfired the color is 2.5Y
7/2, light grey, and after firing to 600° it is
10YR 7/3, very pale brown. This clay bed along
the Wadi Nuᶜeima could have been the source of
some of the Neolithic pottery.

Clay no.4 from the Pre-pottery Neolithic A
(round houses) brick shows the same characteris-
tics as clay no.3 but for one large rounded quartz
grain found in it. Needless to say, clays no's
2 and 3 only resemble those used by the Neolithic
potters but need not be identical.

The Clay Paste
This was analyzed for siltiness, the presence
of microfossils, chert, other impurities like
occasional coarse calcite or lime grits, and frag-
ments of clay not mixed with water when the clay
was prepared. The silty clays contain fine quartz
grains <0.05mm. in varying quantities, from 10 to
2 or 3 grains per 0.25mm^2. The non-silty clays
may contain a few quartz grains per mm^2. or more.
Practically all the sherds contain microfossils.
The amount and size can vary considerably, as does
probably the age. Occasionally one finds angular
chert grains probably not added on purpose and
this also is the case with isolated small and
large lime- or calcite grains.

The Temper Groups
They are divided into grog, organic material,

the carbonate group, quartz and pounded shell.
The grog was analyzed again for silty and non-
silty clays, and for the temper groups of lime or
grog. Organic material was studied on the sherds
but thin-slides were used to study the added non-
plastic temper. Next the carbonate group was di-
vided into lime, chert and calcite. Few sherds
contain quartz-sand temper or pounded shell.

Texture
 The texture is defined according to the grain
size of the non-plastic impurities found in the
clay paste. Often in this pottery one finds a
wide variety in grain size. I have noted the
largest sizes and not the average according to the
following standard.
Very coarse >1mm. in diameter; coarse 1mm.-0.5mm.;
medium 0.5mm.-0.25mm.; fine 0.25mm.-0.10mm. and
the amount. Very coarse has no upper limit.
The distinction between Group 1 and Group 5 is
made by looking at the sherds and not from the
thin-slides, because the surface treatment has
also to be considered.
 This analysis is not a study for its own sake
because it has to be related to the total process
of potmaking. The first thing to be noticed is
that the division between silty and non-silty
clays is not so hard and fast. In the silty clay
the amount of quartz varies greatly, although the
majority of the sherds contain much quartz. There
is a sliding scale from much to very little or
none at all. Sherds that contain bits of clay
that were not broken up in the water often show
the same amount of siltiness in clay and clay
paste but there are few sherds that have silty and
non-silty clay grains. It seems possible that the
clay bed contains layers of silty and non-silty
clay. Depending on how this clay was dug and
mixed the amount of quartz can differ. In the
same way the amount of microfossils can vary.
Eight sherds have no microfossils. Five of these
sherds have other peculiarities and four are made

of non-silty clay. One sherd has red slip on a
light-firing slip. In contrast to the sherd it-
self the white-firing slip is full of microfos-
sils. The sherd has no temper. Two sherds in
this group contain sandstone grains, one has a
silty paste, and both have very coarse quartz
temper. They certainly came from elsewhere. One
sherd has felspar grains, very low siltiness and
is also to be considered as foreign. It is not
surprising to find occasionally one or two grains
of chalk, chert or calcite in a sherd which has a
different temper. The surface near tell es-Sultan
consists of this material.

It can be demonstrated that at least partly the
grog comes from pounded pottery. It contains it-
self the well-known tempers from this period:
grog, chalk or calcite. There is grog from silty
and non-silty clays, and even non-silty grog mixed
with a silty paste. There is no notable differ-
ence between the paste mixed with grog and paste
mixed with other types of temper. The potters who
used broken pottery found the sherds on the sur-
face and this shows that different tempering
methods occurred simultaneously. This temper is
very coarse, only occasionally medium, and the
amount ranges from 1-10 grains per $0.25cm^2$. It is
of course not possible to see whether pottery
mixed with organic matter was also used as grog.
But since the combination grog + organic matter is
fairly common, this must also have been the case.
There is a distinct difference between coarse and
fine organic matter. Chopped grasses (?) were
used and probably dung for the fine temper, which
seems to be more common.

Chalk, chert and calcite are found together or
in the different combination of two minerals.
Sometimes chalk is the sole temper. In three
cases calcite is found without the two other min-
erals and in these cases the sherds seem to have
other features that give reason to isolate them.
One is combined with quartz-sand and this, we
assume, is foreign to the Jericho tradition.

The other two sherds have calcite as a selected
temper. The texture is medium and very coarse.
Five sherds contain quartz or sandstone, four in
combination with grog, and one with calcite.
Two sherds contain exclusively pounded snail shell
and one has snail shell and calcite. One sherd
has no temper at all but contains much more iron
in fine grains than the other sherds. The five
sherds with quartz can be considered as foreign to
the Jericho pottery, with the sherd containing fel-
spar grains. The other exceptions could represent
experiments made by the potters, but until larger
groups can be isolated and studied for other fea-
tures this remains an open question.

Grog as the only temper is found eleven times,
the combination grog + organic matter twenty-two
times; chaff alone is found six times. The combi-
nation of all three groups four times and the
chalk group alone twenty-three times.

9. COLOR

The question of the red-firing and the light-
firing clays remains a problem. It is certain
that the two types of clay were used for the pot-
tery. The red slip is also a red-firing clay.
One thin-slide with a red slip painted on a thick
layer of a light cream slip shows clearly the dif-
ferences between the two layers, and also the sherd
itself.

A number of sherds from all five temper groups
showing a wide variety of colors were refired to
$850^{\circ}C$. This resulted mainly in the appearance of
three different colors: 5Y 8/2, pale yellow; 10YR
7/4, very pale brown and 2.5YR 6/8, light red.
The red slip layer can be much darker but this is
the result of complicated chemical processes that
take place at the surface of the sherd. Here the
interaction takes place of the surface salts, the
iron and the gases of the fuel which may even
cause the iron from the slip to volatilize and

partly to disappear.

The colors mentioned are those that are visible
in a fresh break. In many cases the red clay can
be found in a fresh break but the stratified group
was not systematically tested on this feature.
In fact our kiln test demonstrates that one has to
refire most of the light colored sherds and the
grey ones in order to see how the sherds react.
At present we cannot say whether temper groups and
clay types can be combined although it seems that
both clays were used for all groups. It is of
course possible that the two types of clay were
sometimes mixed like temper groups were mixed.

10. FURTHER OBSERVATIONS

A number of other observations made have been
condensed in Chart 1. The groups are the temper
groups indicated in the previous sections.
Group 5a has a coarser non-plastic temper than
Group 5b, but both can be distinguished from Group
1. Decorated refers to the application of a red
paint. This paint consists of a red-firing slip
which cannot be made from the Quaternary clays
which we tested, unless the potters added some
kind of ferri-oxide to the slip. But there is
definitely red-firing pottery in this repertoire,
and this type of clay may have been used to make
the paint.

Sometimes this paint was applied on a layer of
white-firing slip. There is no sherd covered with
a white slip only.

Bloom does not necessarily indicate that salt
was added to the clay paste by the potters.

Even surface color indicates a developed method
of firing the pottery. Lack of dark cores in the
sherds does not necessarily indicate high tempera-
tures but prolonged firing in an oxidizing atmos-
phere.

Grog temper in Group 5 indicates that those
sherds contain a mixture of lime and grog temper.

11. TWO QUESTIONS

Two questions arise from this collection of material evidence. The first is to find and formulate the factual evidence relevant to the question of relationship. The evidence from the material consists of the following aspects:
1. Clay and clay composition
2. Clay treatment (method of making, tools, firing)
3. The finish given to the pottery (decoration)
4. Shape.
Secondly, the degree of coherence between these four aspects and the degree of continuity in the work of the potters has to be found. For practical purposes, the following definition is given as to what is considered coherent between the four aspects: Features that have been observed should not contradict the physical possibilities of working with the clay and of potmaking, and any change observed should follow logically out of these possibilities. This means that as much as possible, any 'development' is explained as a development of the craft of the Neolithic potters, unless features are observed that have no relationship with an 'earlier' stage.
The picture thus obtained is necessarily independent of stratigraphy. As soon as the stratigraphical evidence is taken into consideration, one enters the field of archaeological interpretation. It is, however, extremely important that the unity and the continuity or discontinuity of the pottery be proven on the evidence of the pottery itself. Once this has been established, a critical approach to the stratigraphic evidence is possible. And vice versa.
The different features have been described in sections 1-10.

12. COHERENCE OF THE ENTIRE GROUP

The coherence of the picture demands that we
talk in terms of 'earlier' and 'later' because
there is evidence of a development in the craft.
For the moment, however, 'earlier' and 'later'
should not be translated in terms of stratigraphy
or chronology.

At the beginning we find two temper groups:
coarse sand and organic material. These groups
can be easily isolated.

Group 3 is a mixture of the tempering material
of Groups 1 and 2. This can also be established.
The mineral grit is the same but found in smaller
quantity than in Group 1. Likewise the same or-
ganic material has been mixed with it as is found
in Group 2. Group 3 pottery can be isolated,
though the proportions may vary with each sherd.
The technique of mixing two clays to combine the
properties of each was very possibly known at this
early stage, after the concept of cultivating
crops had been put into practice. It can thus be
deduced that Group 1 and Group 2 were used before
Group 3 was created. Therefore Groups 1 and 2
must be the earlier ones.

The main temper of Group 4 consists of crushed
fired clay. This may have come from two sources:
1. Crushed pottery
2. Crushed clay from broken-down kilns.

That kilns of some kind were used is fairly
certain (see Chart 1: Even surface color, and
Dark core). Some of the fired clay particles are
vitrified, which means they were fired to melting
point, about 1200°C.

Many sherds contain nothing but crushed fired
clay (grog). However it is obvious that there is
no break between the pottery tempered with organic
matter and the pottery with grog. A fair amount
of pottery is found which has a mixture of both
ingredients, but the combination of the three
groups also occurs. Thus there is again a 'tran-
sitional stage'.

It is hardly likely that grog was used before
organic temper for the simple reason that one must

have fired pottery in the first place to be able
to mix it with clay in preparation for potmaking.
There is plenty of room for speculation. The pot-
ters working with organic matter who tried the
mixture with Group 3 clay may have arrived at the
idea that if stone needed to be added, crushing
pottery was the easiest way to get fine particles,
and also that mixing grog was less difficult than
mixing two types of clay. They were aware of grit
size and the need for small grit. Using small
sized crushed stones would have required a sieve.
The development would thus be from adding grog to
a clay tempered with organic to adding organic
material from habit in smaller and smaller quanti-
ties, until it was entirely omitted.

Once this stage had been reached, there was a
great demand for broken pottery. Because the
firing methods were well developed, the time may
have come when there was not enough grog available.
But by then the potters, knowing that the temper
had to be as fine as possible, started mixing the
clay with fine stones using a sieve. Likewise the
same process followed again from a transitional
stage, where both kinds of temper were used, to a
mixture without grog.

Thus we find the following situation. To begin
with, there were two groups. These two groups
were combined to form a third. From Group 2 the
transition to using grog developed without a sharp
break. The third group was meanwhile still in ex-
istence because occasionally the combination of
grog and organic material occurs. Then Group 4
evolved without any organic material.
Again a transition took place without a sharp
break, forming Group 5 - a 'pure' group with
mineral tempers (see Chart 2).

13. CLAY TREATMENT, FINISH AND SHAPE

This interpretation is based on the study of
the clay and the clay composition, and how it

relates to
1. The clay treatment
2. The finish
3. The shape.

The Clay Treatment

Groups 1 through 4 were all treated in the same way. The pottery was built in coils and scraped inside and outside with a flint tool. The edge of the tool was never wider than approximately 1cm. and was usually smaller. There are traces of vertical scraping to pull the clay upwards, but the finish on the inside and outside was primarily made with a horizontal movement. Quite often there are traces of treatment with wet leather to smooth the surface.

Rounded bases were probably shaped in pottery moulds (the insides of bases from broken pots). Organic material was used to prevent the clay from sticking to the base on which the pot was being made. Pots were not turned during the process of making. (For Group 5, see below.)

The Finish

No pots of Group 1 were found to be painted. This is not surprising, since the large stone grit content renders the surface unfit for painting. In contrast, Group 2 can easily be evenly painted because the surface is not covered with non-absorbing stones.

The pottery from Group 4 is more complex. Some of the grog was fired to the sintering point (the point at which the clay ceases to be porous), and paint did not easily adhere to the surface. So a slip was developed which provided a smooth surface to which the paint could be applied - a technical achievement. This slip is a carbonaceous clay (it is very light firing) and since its shrinkage is heavy, it could not possibly be applied to Group 1 pottery where the shrinkage was greatly reduced by the large amount of temper used. There would have been uneven shrinkage between pot and

slip. Thus the slip was best applied to Groups 2
and 4. It failed again on Group 5, the pottery
with the stone temper.

 The handles are another significant aspect.
Group 1 has handles which are strongly reminiscent
of the tradition of making handles of pure, plas-
tic clay by 'pulling' - that is, by shaping a roll
of plastic clay between the thumb and forefinger.
The handles of Group 1 were made from the same
lean clay as the pots, producing a strong adhesive
quality. The amount of shrinkage is small, and
the coarse temper makes for a further strongly ad-
hesive element. This is not the case with Groups
2 and 4, where the handles tend to break loose
from the sherds. Consequently these are either
very small, especially on the painted pots, or
they are replaced by knobs. And here another tra-
dition began: the loop handles were replaced by
knob handles. These were pierced by a pointed,
hollow reed (in later pottery one can often recog-
nize the section in the hold), and from this tra-
dition the ledge handle could develop. Again we
find a purely technical reason explaining a
change.

The Shape
 There are no great shape differences in Groups
1 through 4. A definite change can only be ex-
pected with the development of Group 5 when an
important new feature begins to appear: the turn-
ing of the pot during its manufacture. But here
again there seems to have been a slow development.
The small rounded bowls in Group 4 are the first
to have been made with a turning movement. This
aspect requires a special study but although there
are many rims of small bowls, there are not enough
bases. It is important to note that the need for
thin walls first becomes apparent with the small
painted bowls. On the whole, the average thick-
ness of the walls in Groups 1 through 4 is 10-14mm.
Smaller pieces are often 8mm., but they are a mi-
nority in the whole repertoire. Only the painted

specimens are 4-6mm. Obviously the potters were
aware of the beauty of a small and delicately
painted bowl. The urge to achieve a perfect shape
caused them to seek a better technique for thin-
ning the walls. The answer: turning the clay
(with a fine temper). This could be done by turn-
ing the mould, if one was used. However, the con-
flicting elements were a change to a mineral tem-
per and the use of a paint which did not suit such
a clay composition.

14. THE TRANSITIONAL STAGES

The introduction of turning as a method of pot-
making is further discussed in section 15. Here
we first have to consider one important aspect in
the method of studying the whole process of pot-
making.

The study of the thin-slides has demonstrated
that the four groups as described above are real
groups that can be distinguished even with the aid
of a good magnifying glass.

The transitional groups are the problem. All
the shords have been studied with the aid of a
large magnifying glass under special lighting.
Moreover, since the break in the sherd is never
clean after washing (a lime deposit remains), we
have broken off a small corner in order to get a
clean break. Often we have used a binocular with
magnification up to 40 times, and a proper grid to
measure the size of the particles. This is really
an uncompromising way of studying sherds because
every single impurity is found; for instance,
small snails that lived in or near the water. In
this way the four groups could be clearly isolated
but the transitional forms are more difficult to
pinpoint. Does one have to go to the extreme of
counting the quantities of organic material and
grog which have been mixed together, and determine
the ratios? This seems fairly useless since it is
based on the assumption that mixing was so

thoroughly done that every sample taken at random
from the edge of a sherd gives a representative
picture of the whole pot. This certainly is not
the case. It is however a crucial point in this
method and one cannot escape the conclusion that
every sherd from the period should be incorporated
in such a study, in order to obtain a more reliable
statistical picture.

15. GROUP 5

Group 5 is quite different from the four that
have already been discussed. This group consists
mainly of what has been designated as Pottery Neo-
lithic B. It is so distinguished after it has
lost the traces of development that it cannot pos-
sibly be confused with Groups 1-4. The question
is therefore: Can Group 5 be a direct descendant
of Group 4, which is the last development in the
Neolithic evolution of the craft at Jericho?
 Group 5 after its development is primarily dis-
tinguishable from Group 4 by the fact that there
are no traces of surface treatment with a flint
tool. Instead we find smooth surfaces and slight
traces of turning. The pots were made standing on
a base which could be turned (an early prototype
of the wheel). In this group the first mat im-
pressions were always found beautifully centered.
 Another indication of turning is that we find
rounded shapes in vertical sections; rims are
turned inward or outward (and a slight carination).
 The grit is stone and not grog. It is 'sand'
taken from river beds. There is, however, an im-
portant difference from Groups 1 and 3, though the
source of the grit is the same. This sand was
taken from its find-spot and then put through
sieves to control the size. Some type of woven
material was probably used. Surprisingly this was
done to some degree of perfection.
 There are thin-walled bowls (4-6mm. thick) which
in section seem to have been made of the so-called

well levigated clays.

Under a magnification of thirty times one dis-
covers two things. First, the ratio of clay to
stone temper is sometimes nearly one to one.
Secondly, the stone has been shaped by transport
in running water, and not by dry crushing. The
smallest particles can hardly be seen with the
naked eye. If one compares this with the grit
found in Groups 1 and 3, the difference in grit
size is immediately obvious. The finest grit was
used for thin-walled vessels. We have to assume
that the potters had found a method of extracting
very fine grit from 'sand' deposits. It appears
that the sand is composed of broken lime and flint
rock, and some shell fragments.

Apart from the fabrication methods (large pots
were still made in coils and then turned) and the
nature and preparation of the grit, the decoration
is also different. Chevron pattern, the use of a
slip, thin oblique painted lines and burnishing
have all disappeared. Small pots have been treat-
ed with a red paint. Bowls are painted over the
entire body, including the base on the inside and
outside. Larger vessels show only horizontal
broad painted bands near the rims or around the
middle. There are no unpainted sherds at all in
this group. This is also a marked difference from
Group 4.

16. THE RELATION BETWEEN GROUPS 4 AND 5

All this taken together points to a new type.
This description refers to a fully developed type
which must have been produced at one time. How-
ever, it did not arrive at Jericho in this devel-
oped stage, nor was this the end of the develop-
ment. Our principle of division is grog or stone
grit. Although there are not many sherds to con-
firm this, in all of the three aspects mentioned
above (turning, temper and painting), one finds
transitions from Group 4 to Group 5.

The first traces of turning are found in Group
4, when the potters made small bowls. Smoothing
the inside with leather was already practiced in
some of the Group 4 pottery, especially on the
painted pottery. Burnishing is occasionally still
found on Group 5 sherds.

Then we find that grog is still added and mixed
with the stone grit in Group 5. Obviously this
habit was slowly dropped, and since the grog is
sometimes of a very small size, it may easily es-
cape detection.

With respect to painting and decoration, the
first appearance of incised lines consists of de-
lineation of the chevron pattern on a sherd that
has only grog temper (Group 4). Grog temper made
painting difficult, and presumably during a short
period the potters tried to improve the result of
painting on this material by drawing lines to give
the pattern definition. This method then develops
a life of its own and on the Group 5 pottery we
occasionally find the incised herring-bone pattern
running horizontally around the painted pot.
Since about half of the surface of the pot now
consists of stones, of which only the lime stones
absorb paint, the paint drips when applied. There-
fore small pots were probably dipped in a bowl of
paint, which explains why sometimes the inside of
a jar-shape is also painted. For the same reason
we find that the paint is applied with a brush to
all larger vessels, the strokes being clearly
visible. The paint does not penetrate as it does
with Groups 2 and 4, and painting thin lines is
impossible. One can often see that the same pot
was painted two or three times over; this was done
while the pot was being turned.

From this we can conclude that the Group 5 pot-
tery developed from a stage where painting was not
a problem, and could be successfully applied.
Since the potters made these pots in a turning
movement, the triangle and chevron pattern did not
have much chance of surviving the new method,
since the paint was also applied while the pot was

being turned. The incised herring-bone pattern,
first invented to support the decoration with
different colors (the color of the slip and that
of the paint) evolved too late to develop into an
independent method of decoration for the same
reason: decoration followed the more mechanical
method of potmaking. Thus it became horizontal
instead of oblique or vertical lines. There had
to be a new influence from somewhere to revive the
art of decorating pots. This came when the potter
began applying plastic clay bands along the rims
of pots.

Handles seem to have practically disappeared
with the Group 4 pottery. Only very small hand-
les, almost too small to be of any use, survive on
the decorated wares of Group 4. In Group 5 one
does not find them on the smaller pots though the
knob handles are occasionally found. A few larger
and extremely well-made loop handles are found on
larger vessels. The clay composition of Group 5,
in contrast to Group 4, would again have permitted
a development of handles but apparently the pot-
ters used knob handles as in Group 4.

The Group 5 pottery consists for the best part
of rims only. The two bases with a high ring can
hardly be characteristic of the bases of this
group. They must be an exception.

17. ADDITIONAL REMARKS

There are some sherds in the collection which
indicate that some important links are missing.
There must have been a period when the combination
of painting and incised lines was often found.
Yet only one sherd represents this group.

Another group that is missing is the stage be-
tween the use of a slip and paint, and the appli-
cation of paint on the whole pot without a free
pattern. What is also lacking is the stage in
which the triangle and chevron type of decoration
dissolved into painting the same pattern in thin

lines on a sherd without a slip. Very few sherds
are present in the collection. It is exactly
these transitional stages which could clarify the
whole picture of the evolution of the potter's
craft.

But on the whole, there is a coherent picture.
Looking at the pottery from the purely technical
side, or from the point of view of the potter,
there is no reason to see any break in the devel-
opment from Group 1 and Group 2 to Group 5. On
the contrary, there is a development right through
the whole group which is somewhat comparable to
the technical development of the Early Iron Age
pottery from Deir ᶜAllā (Franken & Kalsbeek,
1969); like the change in shape that is connected
with a method of quicker turning, and the applica-
tion of paint to a surface that is no longer suit-
able for painting, including the transition from
decorating in different directions to decorating
in horizontal bands. To name only a few.

The actual shape and the details of shape
development have been omitted from this part of
the report. However, most shapes that are 'diag-
nostic' have been drawn and arranged according to
the five groups distinguished in this report
(see Figs.1-7).

Proper construction drawings for the different
groups and types have not yet been made. Better
knowledge of exact shape is required for this type
of drawing, and this can also be obtained only
from a larger collection of sherds.

On the whole, the pottery has been well fired.
There is hardly a sherd with a black core in
Group 5 and on the whole, even the thick walls
were fired to an even color. This cannot have
been achieved by firing in an open fire. There
were firing chambers in which a fairly even tem-
perature was obtained and held long enough for the
pot to fire uniformly. Misfirings are totally
absent, a sharp contrast, for instance, to the
Early Iron Age pottery from Deir ᶜAllā. And it
seems that fairly high temperatures were often

reached. The pottery was fired in an oxidizing
atmosphere.

Statistically, the figures given in the charts
are not very convincing. This is primarily be-
cause further material is needed to obtain a more
reliable picture. Only Group 5 is clearly a de-
velopment during the period under discussion. But
the interpretation of the numerical facts in ar-
chaeological terms, or relating this picture to
the stratigraphic situation and to the Pottery
Neolithic culture as a whole, is not the subject
of this study. It is hoped, however, that the
correlation of the cultural and anthropological
aspects of the pottery will be a subject of dis-
cussion.

All the features observed on the pottery and
those listed in Chart 1 have been condensed into
a survey in Chart 2. From the point of view of
the potter's craft it shows a coherent picture of
development. For instance, it is shown that Group
2 was not suddenly replaced by Group 4, or Group 1
by Group 5. Chart 2 indicates transitions where
a mixture of different grit is found in the
sherds. It also shows the direction of the de-
velopment.

'Primitive' is a relative qualification. If a
culture has a well developed technical level but
pottery techniques are not on an equal level, one
may call its pottery primitive. In this sense
Neolithic Jericho cannot be called primitive.
These potters were very actively working, experi-
menting, trying new possibilities. They even
refused to use anything that was fired too low or
too high. When they discovered a new technique
they were likewise confronted with new problems.
Thus in Group 5 they could make large vessels with
very thin walls - a skill which shows the well
developed nature of the craft.

One more aspect should be mentioned. Turning
is not a logical development in itself. Very
often one sees that in static communities no de-
velopment towards turning takes place. Just as it

is the case with the Neolithic pottery, some of the
artistic value is inevitably lost when potters be-
gin using a turning base, and it may take a long
time before turned and thrown pottery acquires the
same quality again. It may very well be that in-
crease in population is, as a rule, the reason that
potters begin looking for quicker methods of pot-
making. The transition from turning to throwing
is even more drastic and the reasons for this
change are likewise external.

18. CONCLUSION

The development of the tradition of Neolithic
pottery as reconstructed in this model is an ex-
ample of a development which cannot logically be
reversed. From the potter's knowledge it is not
logical that Group 3 is an earlier stage than
Groups 1 and 2. Even the following stages of de-
velopment cannot be placed in a different order.
This logic is based on the way an experienced pot-
ter looks at the possibilities of the raw materi-
als and the different mixtures of these materials.
Hence the whole reconstruction hinges on the ana-
lysis of these materials. Likewise we know now
that the Jericho pottery is not an isolated group.
Small quantities of pottery were found which were
not made there. Superficially it cannot be dis-
tinguished from the main group. However, pottery
that contains sandstone is almost certainly not
locally made.
Dr. Kenyon's division of the material in Neo-
lithic A and B groups is grounded in her strati-
graphic study. We have, in fact, added another
distinction which is equally important; our Groups
1 and 2 that are also found at the beginning of
this period on the tell. It is not only possible
that Groups 1 and 2 arrive at the same time, but
it is possible that Groups 3 and 4 also existed
right from the earliest phases. Our model does
not imply that potmaking was invented at the site.

The knowledge of potmaking migrated to the site.
If it can be shown on the basis of the strati-
graphical evidence that Groups 1 and 2 are indeed
the earliest groups and that 3 and 4 developed at
the site, then we can assume that there were two
methods of potmaking known to the potters. But
before these people came to the site, knowledge
about the other groups may have already existed.

Dr. Kenyon has attributed a group of painted
vessels from our Group 4 to the Neolithic B group
on the basis of the stratigraphy. And she has
made it perfectly clear that Neolithic B pottery
supersedes the A pottery on the tell. This is
either independent evidence for the relation be-
tween the A and B pottery or for the relation of
the temper groups 4 and 5 at a different site.

The model makes it clear that this pottery tra-
dition was not restricted to one site, that dif-
ferent stages of development may have occurred
side by side in a limited area and that there were
connections between the pottery making population
groups. This study should not only be extended to
all the Neolithic pottery found near Ain es-Sultan
but also to pottery from the neighborhood like the
Ghrubba pottery (Mellaart, 1956), pottery from
cAin Duq and other sites.

Chart 1

Chart 1

Groups	1	2	3	4	5a	5b
Total of sherds - undecorated	36	37	132	224		
- decorated		18	27	140	93	96
Bloom on undecorated sherds		12	8	34	61	
Most frequent thickness in mm.						
- undecorated	10-12	8-14	10	8-12		
- decorated			6-10	6-10	6	6-10
Even surface color						
- undecorated	31	32	111	206		
Dark core - undecorated	7	7	39	36		
- decorated		3	3	27	1	1
Rounded bases - undecorated	4	4	11	8		
- decorated			1	6	4	5
Loop handles - undecorated	4	2	4	21		
- decorated		1		9	1	5
Knob handles - undecorated	1	2	1	4		
- decorated				2		2
Rims - undecorated	14	8	65	97		
- decorated		6	11	55	47	49
Painted - chevron				11		
- fine stripes				9	5	
- band			1	20		28
- evenly		18	24	102		131
Engraved decoration				2	7	
Painted and burnished						
- exterior		13	25	95	10	
- interior		2	9	25		
Grog temper in group 5					24	1

Chart 2 211

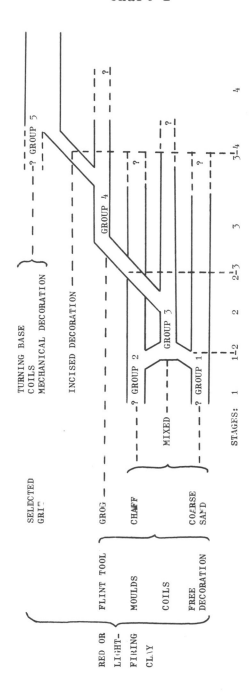

GROUP=TEMPER GROUP

Figure 1

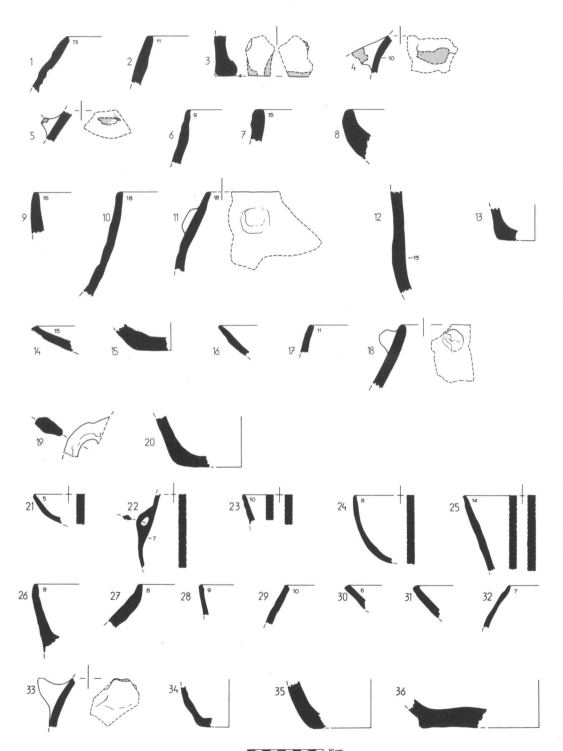

Figure 2 213

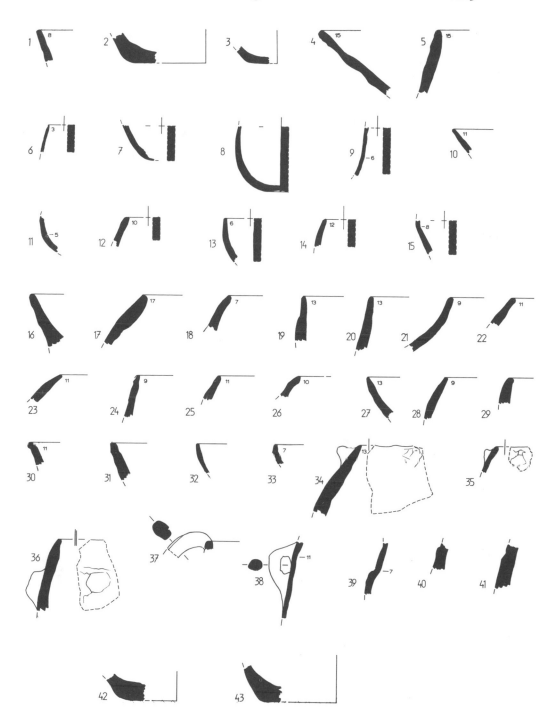

Figure 3

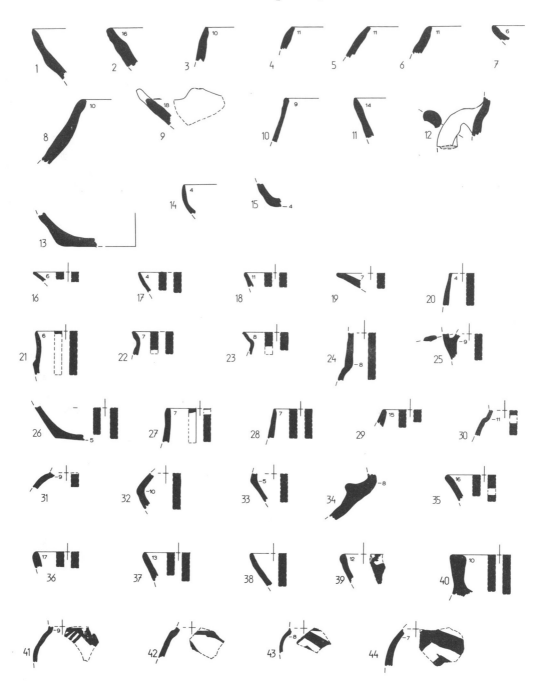

10 cm

Figure 4 215

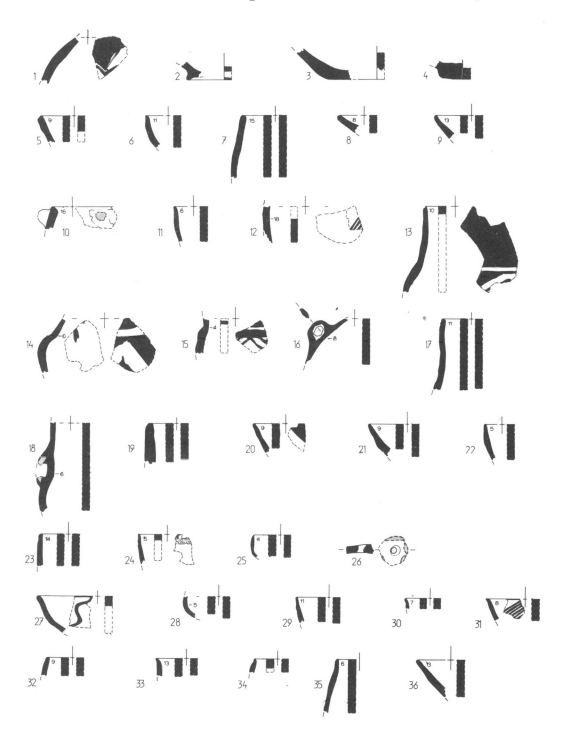

10 cm

Figure 5

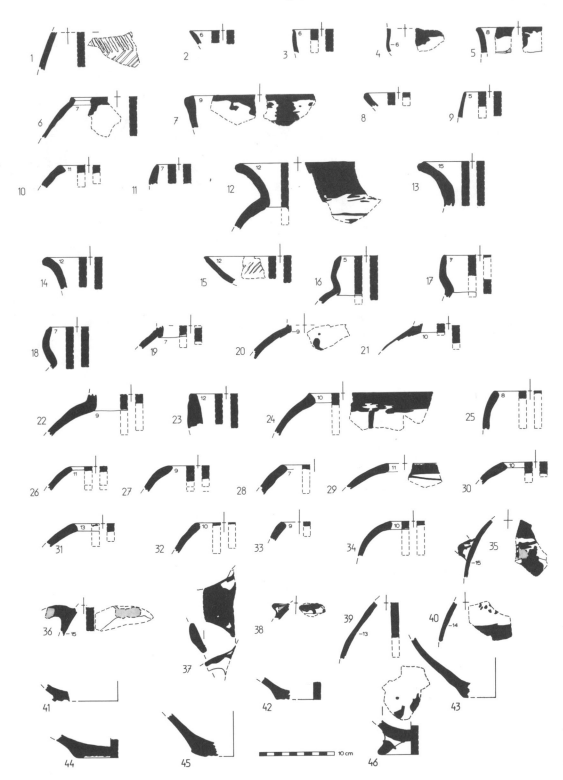

Franken, Henk J. & Kalsbeek, J., 1969. Excavations
 at Tell Deir ᶜAllā, I, pp.162ff; 172ff;
 Leiden

Kenyon, K.M., 1957. Digging up Jericho, Ch.5;
 London

Mellaart, J., 1956. The Neolithic Site of
 Ghrubba, pp.24ff. Annual of the Depart-
 ment of Antiquities, Jordan, Vol.III

Picard, L.Y. & Golani, U., 1965. Israel Geo-
 logical Map, Northern Sheet